THE ARCHITECT & SCULPTOR RAs

THE ARCHITECT & SCULPTOR RAs

A guide to the Architect and Sculptor members of the Royal Academy of Arts with examples of their work

Dennis Toff

Unicorn Press

Unicorn Press
47 Earlham Road
Norwich
NR2 3AD

email: unicornpress@btinternet.com
www.unicornpress.org

ISBN 978 19065 09088

Designed by Karen Wilks
Printed in Slovenia

Front cover:
Plan – Waterloo International Terminal courtesy Grimshaw Architects
Sculpture – 'Echo 2008' Courtesy Nigel Hall RA
Back cover:
The Queen Elizabeth II Great Court, British Museum
Courtesy Spencer de Grey CBE RA, Foster + Partners and the British Museum

to Jacqueline for her further patience and help

A photograph is a meeting place where the interests of the photographer, the photographed, the viewer and those who are using photographs are often contradictory.
John Berger

In making a portrait the photographer must forge a harmony between the aspirations of the sitter, who wishes to look his or her 'best', and the expectations of the viewer who seeks the 'identity' of the subject.
Dennis Toff

When George III agreed to set up the Royal Academy of Arts in 1768, he took an enormous risk. Why did he think that a disparate group of artists of all different backgrounds and ages would actually want to talk to each other? Why did he think that Painters would want to talk to Architects, or that Sculptors and Architects had anything in common?

Maybe he used his Royal influence to force the issue. But he certainly provided the spark that lit a fire which has been burning ever since – sometimes quietly and sometimes (as when Munnings railed against Picasso) becoming a raging inferno.

The fact is that Members have always been happy to mix together, to argue, discuss and debate. Somehow the institution, even though it has moved a few times, has always been conducive to this. An artist's life can be a lonely and obsessive one and to have somewhere to meet a fellow practitioner, perhaps over a glass of wine, and to exchange views in an atmosphere of mutual respect and fellowship, is surely quite a rare thing. This general ambiance has persisted and is as true today as it was in 1768.

Writing, as I am, the 25th President in 241 years, I wish to commend Dennis Toff for his photographic record of virtually all of the existing architect and sculptor Members – a wonderful sequel to his book on the Painter RAs published in 2008. He has for the most part photographed the artists at work in their studios or work-places. And in most cases, I think he has captured in his subjects something of the dynamic that drives an artist to create.

It has been a complete joy to me to know almost all of the Members here recorded and to chair the many Council meetings and General Assemblies that we all assiduously attend.

Sir Nicholas Grimshaw
President

This is my second book of portraits of the members of the Royal Academy of Arts, the Royal Academicians. Together with the first book, *The Painter RAs*, it completes my project to produce a record of the current membership which had not been attempted since George Dance's drawings of 1793.

The public tend to know little about the Painters, Architects and Sculptors whose works they see and admire at the annual Summer Exhibition: the roles which they, the permanent staff and the Secretary and Chief Executive, Dr Charles Saumarez Smith, play in managing an independent Gallery and School without public funding. In these two small books I have attempted to fill that gap and hope readers will enjoy seeing the faces behind the works.

Currently there are 52 Architects and Sculptors of whom five live abroad. I have tried to include all the others but perhaps inevitably there were two who did not respond to my invitation to participate. My thanks to the President, Sir Nicholas Grimshaw for kindly agreeing to write the Foreword, to Dr Charles Saumarez Smith for checking my facts, to the 47 Members who are included, and to the staff of the RA, in particular Tessa Abineri, Assistant to the President, without whose help contact with several Members would not have been possible.

In our own age it appears that anything which one says is art is art, but when the Founders formed the Royal Academy towards the end of the 18th century 'to promote the arts of design', it was in an age when the Classical, Palladian, Neo-Classical and Gothic styles prevailed with the painters, sculptors and architects whose shared thread was the pursuit of the ideal. In later times the interests of the disciplines represented by the Academy seemed to diverge with art often exciting a gamut of emotions including horror, shock, discomfort and disbelief as well as enjoyment.

The painter/printmaker working to present a surface design on a reliable support compares with the sculptor who, adding an extra dimension, may need also to consider constraints of environment and weathering affecting his work. Meanwhile the architect, used to heavier responsibilities including the needs of structural stability, internal functionality and planning law, has only recently found greater freedom of expression through the use of revolutionary new materials, design and building techniques.

The Spanish architect, Santiago Calatrava claimed that 'architecture is the art closest to people after the clothes that we wear, of course. It's a very intimate thing. The space where you live, create, love, eat, pray and sleep envelopes you from all directions, it becomes your second skin'.

Today, new materials and techniques offer the development of exciting shapes limited only by the imagination of their creator. We are witnessing the coming together and crossing over of the separate disciplines traditionally united in the membership of the Royal Academy.

The Royal Academy of Arts was founded in 1768 by a group of leading artists under the patronage of George III with 40 Members and 20 Associates very much in control of their own destiny and receiving no State funds. The Academy was first housed in Pall Mall, moved to Somerset House and later it shared premises with the National Gallery until moving to Burlington House in 1867. The first President, Sir Joshua Reynolds, established it as a school to train artists in drawing, painting, sculpture and architecture.

• Academicians are nominated and elected by existing Royal Academicians into one of the four categories of Membership. ie, Painters, Sculptors, Architects and Printmakers. All elected Members have to donate a representative work to the Academy's Collection. This is termed a Diploma Work.

• There are 80 RAs (excluding Seniors) of whom there must be at least 14 Sculptors, 12 Architects and 8 Printmakers. Vacancies arise either on the death of an RA or as they reach the age of 75 and become Senior Academicians. Although there are currently 21 women RAs, Laura Knight, in 1936, was the first to be elected since the original two foundation Members, Angelica Kauffman and Mary Moser.

• The Academy is self-governing with the President re-elected each year, usually unopposed, though unable to serve for more than 10 consecutive years. The present President is the Architect Member Sir Nicholas Grimshaw.

• The Schools are the responsibility of the Keeper, currently Professor Maurice Cockrill RA, who is serving his second 3-year term.The Treasurer is elected for 5 years and is currently Professor Paul Huxley RA.

• The Council comprises the President and 13 other RAs, all members being eligible to sit for 2 years by rotation and a further 2 by election. Council may also include up to 3 external members. The varying activities of the Academy come under a variety of Committees of Members aided by Senior members of the RA staff.

• The establishment of the Royal Academy gave its Members the opportunity to exhibit and sell their work at the Summer Exhibition. Each Member is able to submit 6 works, members of the public can also submit work (send-ins) which is selected by the Summer Exhibition Committee. Approximately 9,000 works are submitted each year from which a shortlist of 2,000 ends up at about 1,200 displayed and seen by 150,000 visitors.

• In Autumn 2009 the RA will be transformed into a company limited by guarantee so that its directors – the RAs – are no longer personally liable for any potential losses. Council members are now directors of the RA and trustees of the RA as a charity

The portraits in this book are of the Architects and Sculptors. The Painters and Printmakers (including Engravers and Draughtsmen) are presented in *The Painter RAs* published in June 2008.

Elected ARA 31st May 1989
Elected RA 26th June 1991

Inebriate Owl 2006
Maquette
Enamel on steel
Courtesy Ivor Abrahams RA

Born 10th January 1935
Leeds, Yorkshire

Ivor Abrahams studied at St Martin's School of Art under Sir Anthony Caro 1952-53 and under Karel Vogel at Camberwell School of Art 1954-57. He was visiting lecturer in Sculpture at Birmingham College of Art and Coventry College of Art between 1960-64, Goldsmiths College, the Royal College of Art and the Slade School of Fine Art. He is Professor of Sculpture at the RA Schools.

Following his first solo exhibition in 1960 he established an international reputation with shows in both Europe and the United States with his work being acquired for Public Collections in both these areas and Australia.

Ivor Abrahams's work is mainly figurative reflecting his environment and using various materials. In his three-dimensional collages, which might originate in manipulated photographs, prints or created components, of portions of structures, animals or landscapes assembled are cut-out to form bizarre but familiar imagery.

His work also includes prints in all media. Although initially against his becoming an artist, his parents collected 98 of his prints and eventually his wife, Evelyne, presented them to the Tate Gallery on their behalf.

He lives and works in London

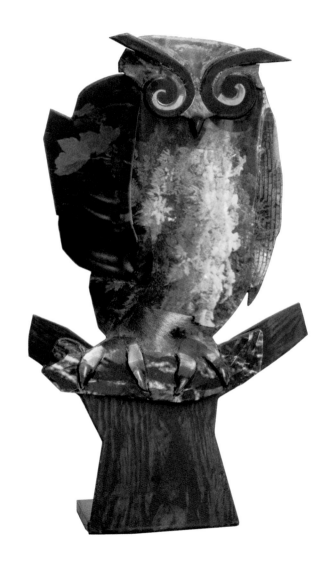

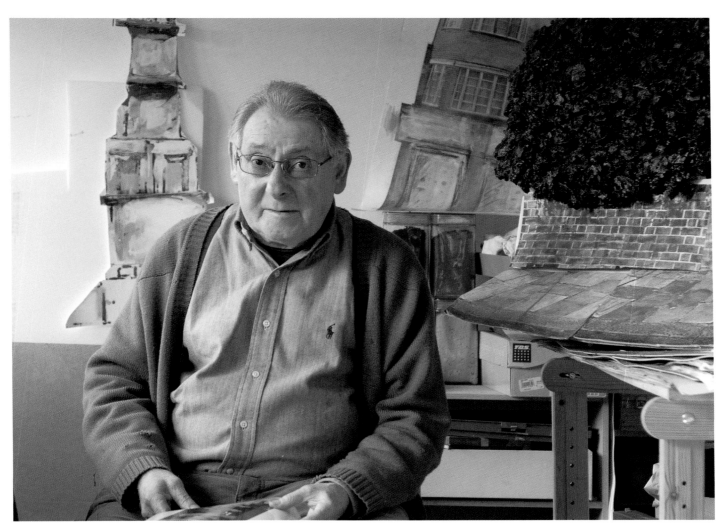

Elected RA 18th May 2000

School of Medicine and Dentistry,
Queen Mary College, University of London
Courtesy Will Alsop and Queen Mary College

Born 12th December 1947
Northampton

Will Alsop studied architecture at the Architectural Association 1968-73 during the years of British 'Pop Art' which was probably equally responsible for his avant-garde architectural outlook.

He worked briefly with Max Fry and Jane Drew before joining Cedric Price and then a short period with Roderick Ham before forming his first practice in 1981. Since then his designs have called upon all three of the Royal Academy's member disciplines combining Architecture, Painting and Sculpture to liberate society from the boredom he believes most buildings produce.

Will Alsop has exhibited paintings and sketches alongside his architecture in the British Pavilion at Venice Biennale and elsewhere. He has taught widely, including Sculpture at St Martin's College of Art & Design, and has held the Chair of Architecture at the Technical University of Vienna since 1995.

Unusually, Will Alsop first explores his ideas in painting before examining the practicalities of construction. He also consults the local community on his designs.

He lives and works in London.

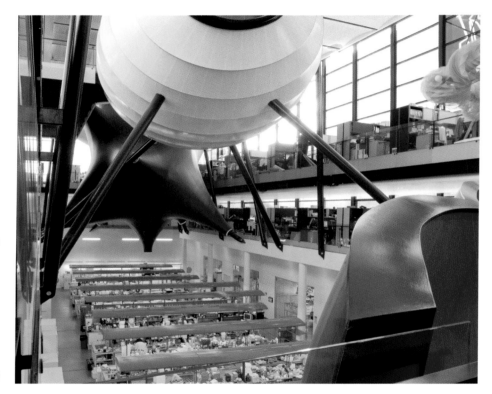

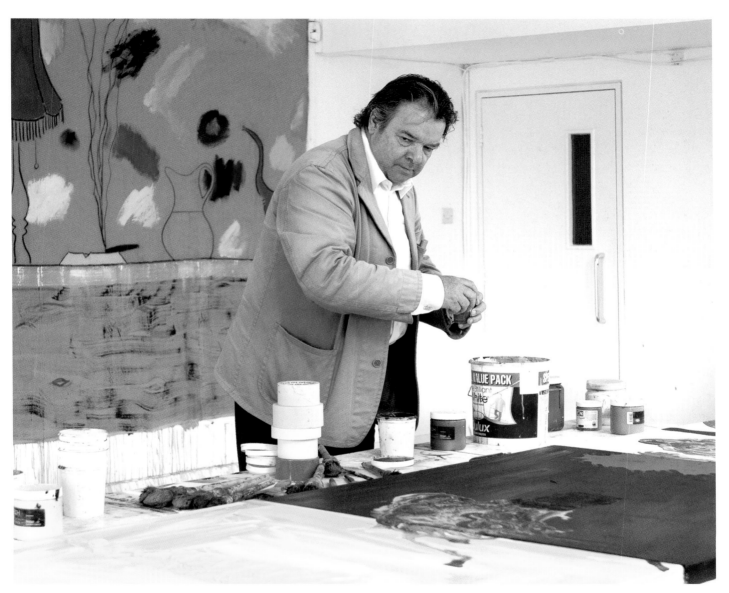

GORDON BENSON OBE RA

Elected RA 18th May 2000

Time Temple, Oshima, Japan
Courtesy Gordon Benson OBE RA

Born 5th October 1944
Glasgow

Gordon Benson studied at the Architectural Association 1966-69. He joined Camden Council's architecture department and expressed his modernism in social housing.

In the mid 1980s he and Alan Forsyth formed Benson & Forsyth forging their response to the high-tech modernisms of the time in 'contextual modernism' a principle boldly presented in their award-winning sandstone-clad extension to the Museum of Scotland in 1991 expressed by the epigraph which ran across the top of their proposals (from Allan Ramsay's headstone in the churchyard opposite the site) 'No sculptur'd marble, here no pompous lay, No storied urn, no animated bust; This simple stone directs pale Scotia's way'. This was followed by the cool elegance of the 4000 m² Portland stone Millennium Wing extension to the National Gallery of Ireland.

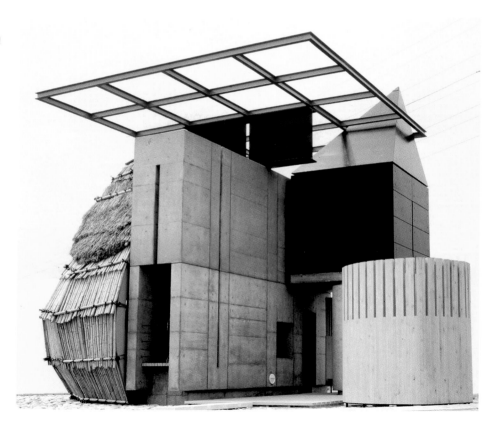

Awarded the 'Power of Aluminium Awards 2008', this time for Hotel and Retail 'Pod' development in Nottingham where the two types of occupancy are presented in different materials – the retail in glazed aluminium sections and the hotel in modernist contoured rendering – contrasting and responding to the location.

Gordon Benson lives and works in London.

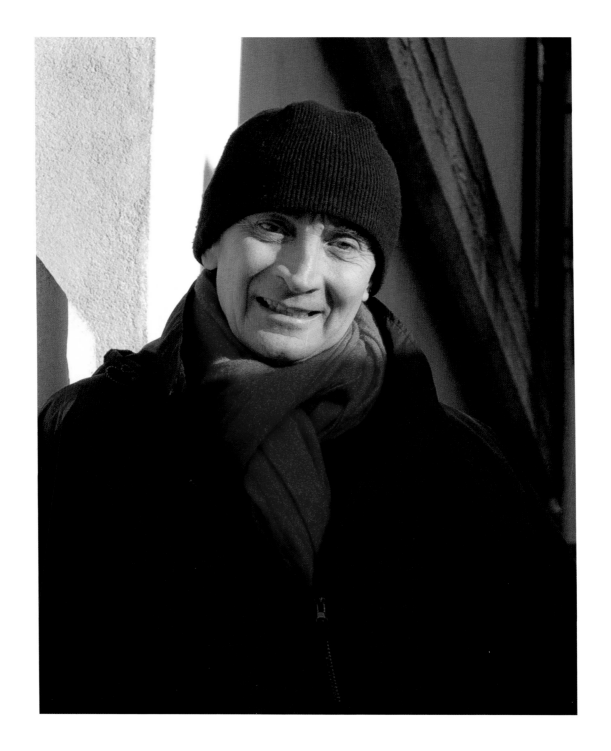

Elected ARA 25th April 1968
Elected RA 15th June 1972

Display No More In Vain The Lofty Banner
Bronze
Courtesy Ralph Brown RA

Born 24th April 1928
Leeds

Ralph Brown served in the Royal Air Force
1946-48 before studying at Leeds College of
Art 1948-51, Hammersmith School of Art
1951-2 and the Royal College of Art 1952-56.
Visiting Paris in 1951 he first saw the works of
Rodin, Giacometti and Richier and a
scholarship there in 1954 enabled him to
study Rodin. Another scholarship took him to
Italy in 1957 where he studied Etruscan
sculpture and the work of Pisano and Piero
della Franscesca with a period making mosaic
panels for Picasso in Cannes.

He was a tutor at the Royal College of Art
1958-73, also at Bournemouth 1956-58,
part-time at the West of England College of Art
before moving to the South of France

His first solo exhibition at the Leicester
Galleries, London in 1961 was followed by
others in Europe and the USA where his
sculptures are in public and private
collections.

His fellow-Yorkshireman Henry Moore
befriended him and bought some of his early
works. Working in traditional materials he
continues with his 'Queen' series of savage
devouring monsters.

He lives and works in Gloucestershire.

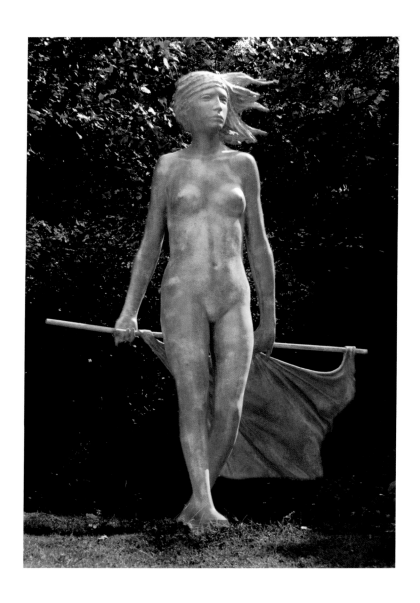

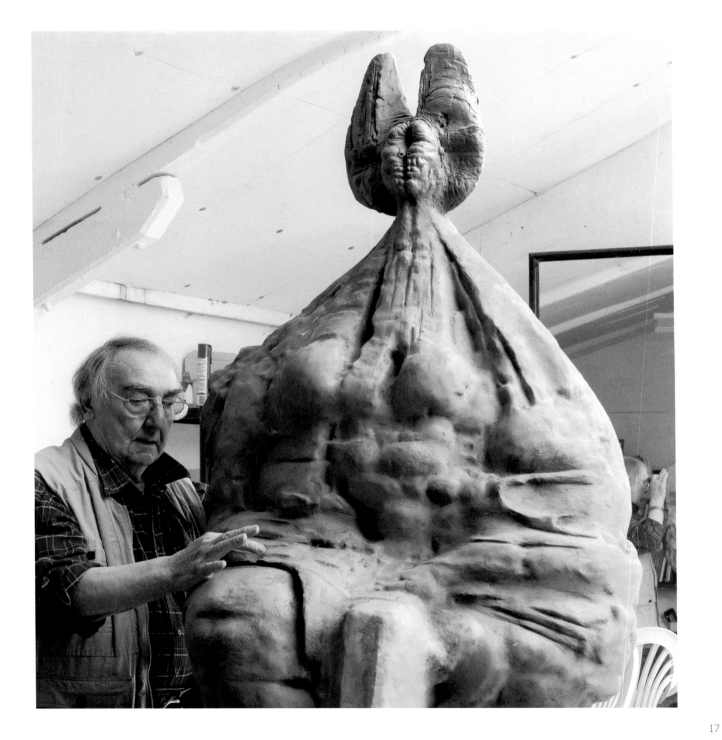

JAMES BUTLER RA RWA FRBS

Elected ARA 24th April 1964
Elected RA 15th June 1972

'Daedalus' Fleet Air Arm Memorial
Courtesy James Butler RA

Born 25th July 1931
London

James Butler studied at Maidstone School of Art 1948-50, St Martin's School of Art 1950-52 and the Royal College of Art, followed by two years' National Service. For ten years he worked with the Master Mason Gerald Giudici cutting stone on restoration work. In 1972 he was commissioned to make a 12ft high statue of President Kenyatta in Nairobi the fees from which enabled him to practise sculpture full-time and obtain numerous other commissions. His statue of Field Marshal Earl Alexander, at Wellington Barracks, his Fleet Air Arm memorial, *'Daedalus'*, on the Victoria Embankment gardens, his delightful *'Skipping Girl'* gracing Harrow's shopping centre, and the purposeful *Burton Cooper* at Burton on Trent are seen daily by thousands. Contrasting in size, in 2000 he won the competition to design the Great Seal of The Realm and in 2004 the 50 pence piece commemorating the 50th anniversary of Roger Bannister's breaking of the four-minute mile.

James Butler's figurative works can be seen in the UK, Africa, the Middle East, France and the USA.

He lives and works in Warwickshire.

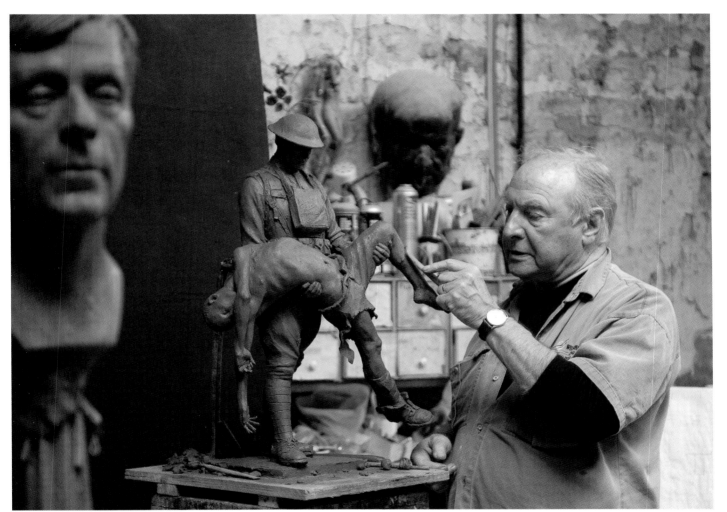

Elected ARA 22nd April 1971
Elected RA 24th April 1975

The Royal College of Art, London
Courtesy H T (Jim) Cadbury-Brown OBE RA

Born 20th May 1913
Sarratt, Hertfordshire

Henry Thomas 'Jim' Cadbury-Brown is the
most senior Royal Academician and studied at
the Architectural Association 1930-35
following which he spent a year in the studio
of the legendary Erno and Ursula Goldfinger.
Winning two competitions in 1938
encouraged him to start his own practice but
a Territorial since 1931, he was called up in
1939 and served until the end of WWII In
1945 as a Captain in the Royal Artillery.

One of the Festival of Britain team who
designed the 'People of Britain' and 'Land of
Britain' pavilions nicknamed 'the wigwams'.
He says he most admired Corbusier and a
German magazine, *Moderne Bauformen*
which illustrated work by Gropius and others.
In 1953 he married the American architect,
Betty Elwyn, who contributed her flair for
detailing in their hallmark works until her
death in 2002.

Among his notable designs are the Royal
College of Art (with Sir Hugh Casson and
Professor Robert Goodden), the 750-unit
housing project at World's End estate,
Chelsea, which he built with Eric Lyons and
his tranquil 1960 home at Aldeburgh.

He lives and works in Suffolk.

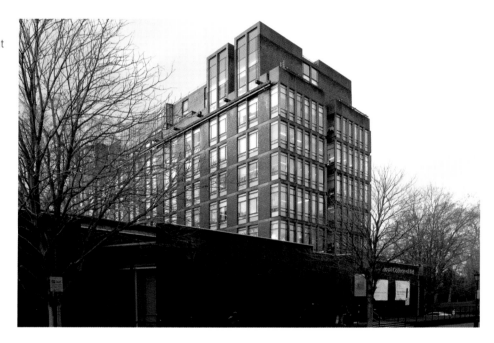

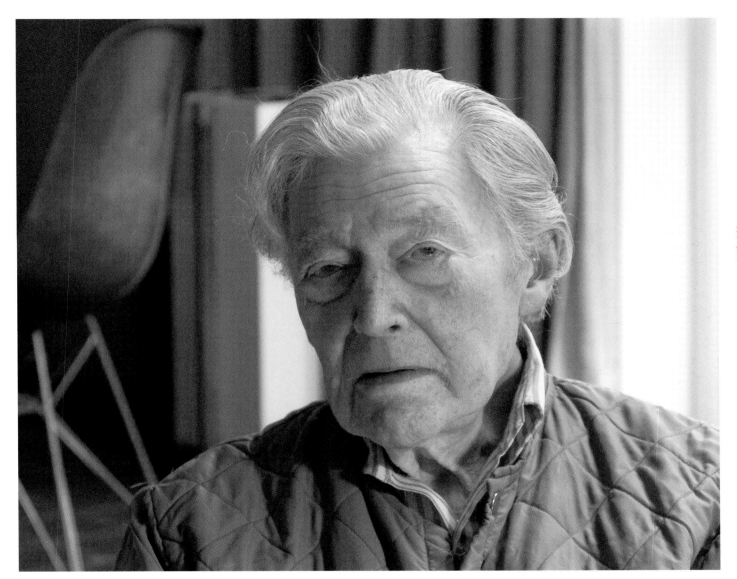

Elected RA 9th March 2004

Chapel of Light
Eglise Saint Jean de Baptiste de Bourbourg
Courtesy Sir Anthony Caro OM CBE RA and
French Ministry for Culture & Communication

Born 8th March 1924
New Malden

While studying engineering at Cambridge Sir Anthony Caro spent vacations at Farnham School of Art and in the studio of Charles Wheeler RA. He served in the Fleet Air Arm from 1944-46 and then studied sculpture with Geoffrey Deeley at the Regent Street Polytechnic (now University of Westminster) followed by 5 years studying and copying classical sculpture at the Royal Academy Schools where he received two silver medals and one bronze.

In 1951-53 he worked as an assistant to Henry Moore and had his first solo exhibitions in Milan in 1956 and London 1957 since followed by worldwide recognition, numerous exhibitions and awards.

Anthony Caro is widely regarded as Britain's greatest living sculptor. He was knighted in 1987 and in 2000 made a member of the Order of Merit.

Most recently his sculptures and architectural features, form a part of the restoration of the Chapel of Light in the 12th-century church of Saint Jean-Baptiste Bourbourg near Calais. The work was inaugurated in October 2008, following seven years in the making.

He lives and works in London.

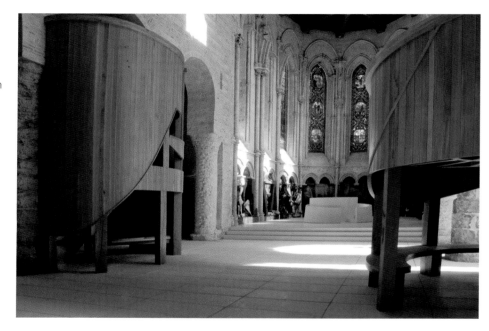

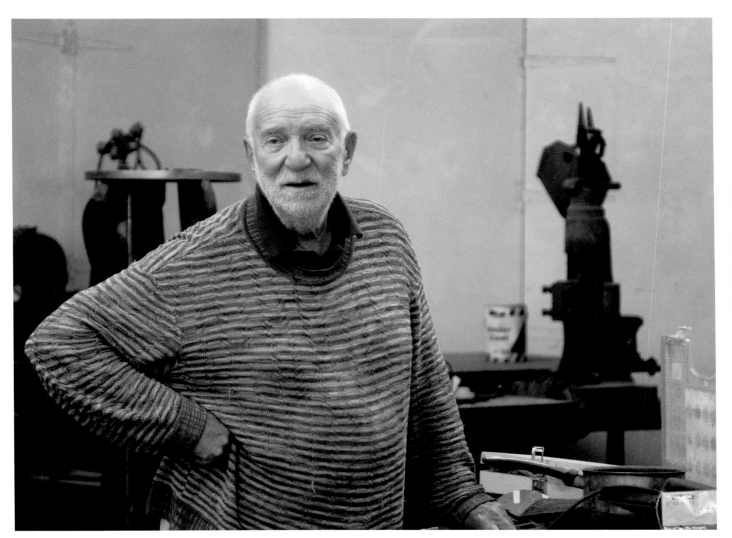

Elected RA 31st May 2007

Four Diagonals 1996
Acrylic with marble powder on plywood
Courtesy John Carter RA
130 cm x 130 cm

Born 3rd March 1942
Hampton Hill, Middlesex

John Carter studied at Twickenham School of
Art from 1958-59, then at Kingston School of
Art from 1959-63, and the British School at
Rome in 1964.

He was assistant to Bryan Kneale in 1965.
He took part in 'New Generation' exhibitions
at Whitechapel Art Gallery in 1966 and 1968.
Following his first solo exhibition at the
Redfern Gallery, London in 1968 he has had
42 further solo exhibitions in UK, Japan and
Europe. An important one at Galerie
Hoffmann, Frankfurt, in 1990, was followed
by many more in Germany. His work has been
in more than 200 group exhibitions and is
included in many public and private
collections.

John Carter has received many awards and
taught part-time at art schools including
Chelsea until retiring in 1999.

His works are mainly wall-hanging abstract
pieces constructed from a systematically
mathematical origin which delight and tease
the viewer. Mostly only a few inches in depth
they are 'cut-out' paintings or sculptures but,
more specifically, 'wall-objects'.

He lives and works in London.

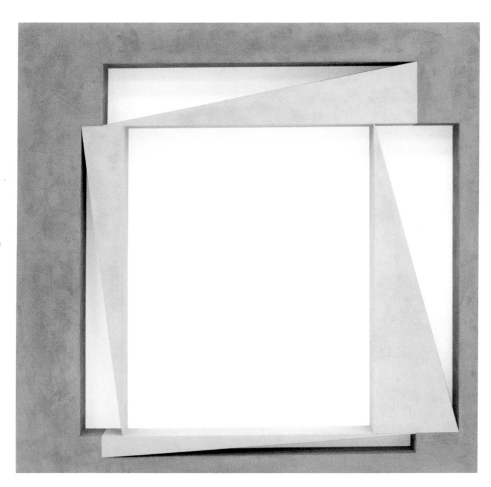

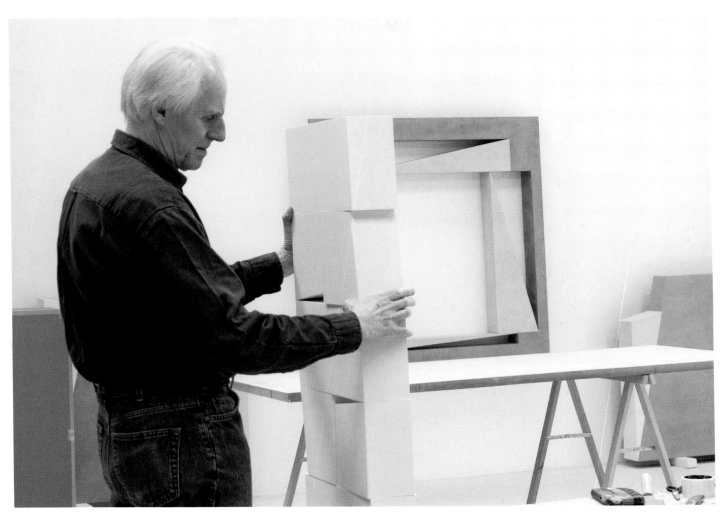

Elected RA 11th December 2007

The Antony Gormley Studio
Courtesy David Chipperfield CBE RA and
Antony Gormley OBE RA

Born 18th December 1953
London

David Chipperfield studied at Kingston School of Art and the Architectural Association, where he was taught by Su Rogers, Patrick Hodgkinson and David Shalev. He later worked in the studios of Douglas Stephen, Richard Rogers and Norman Foster, before setting up his own practice in 1984. David Chipperfield Architects now has 200 staff, offices in London, Berlin, Milan, and Shanghai. Their work is renowned for its simplicity and clarity, displayed via well-proportioned spaces and exceptional attention to detail.

New building projects include the Stirling Prize-winning Museum of Modern Literature, Marbach and the America's Cup Building 'Veles e Vents' in Valencia. Also historically-sensitive restorations such as the Neues Museum in Berlin, the San Michele cemetery island in Venice, and the new commission to redevelop and refurbish The Royal Academy's building at 6 Burlington Gardens. David Chipperfield has won many awards and was made a CBE in 2004. He has taught and lectured extensively in Europe and the USA.

He lives and works in London.

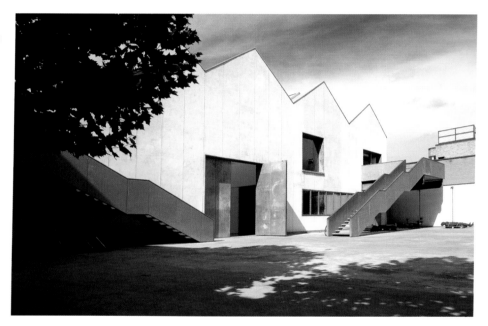

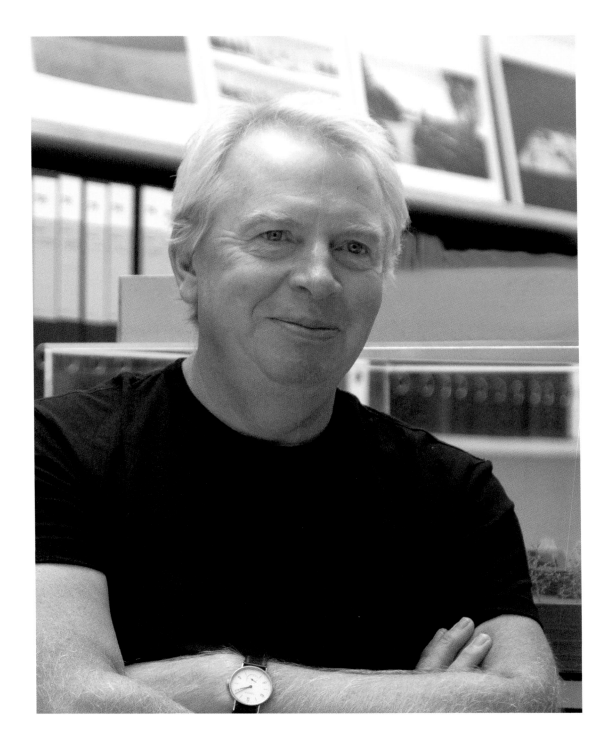

DAVID CHIPPERFIELD CBE RA

Elected ARA 21st May 1980
Elected RA 7th December 1989

Silent Shadow 1997
Bronze, aluminium and stainless Steel
Courtesy Ann Christopher RA and
Linklaters LLP
Height 2.36 m

Born 4th December 1947
Watford

Ann Christopher studied at Harrow School of
Art 1965-66 and the West of England College
of Art 1966-69.

Her first exhibition in 1969 has been followed
by numerous solo and group exhibitions of
her abstract sculpture, drawings and collages.
Working mainly with metals and cast bronze,
her sculptures have been commissioned for
many private and public spaces worldwide.

Ann says, 'For some strange primitive reason
the need to be making a sculpture or drawing
is as necessary as food and water and one's
whole existence feels challenged if this is not
happening. The power of a place can make it
happen – the place is where and when, the
place is where you are and where you are
meant to be – the mystery is why it comes out
the way it does.

There is also the additional effect of time and
the sometimes disturbing emotional content
from one's life journey which contribute to the
mystery that produces the work.'

She lives and works near Bath.

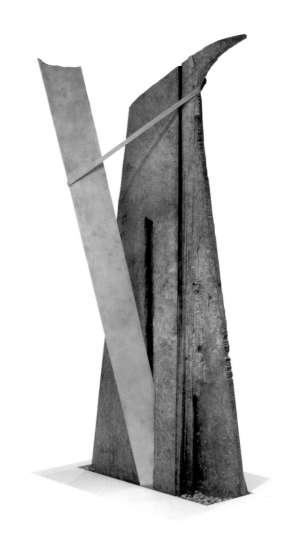

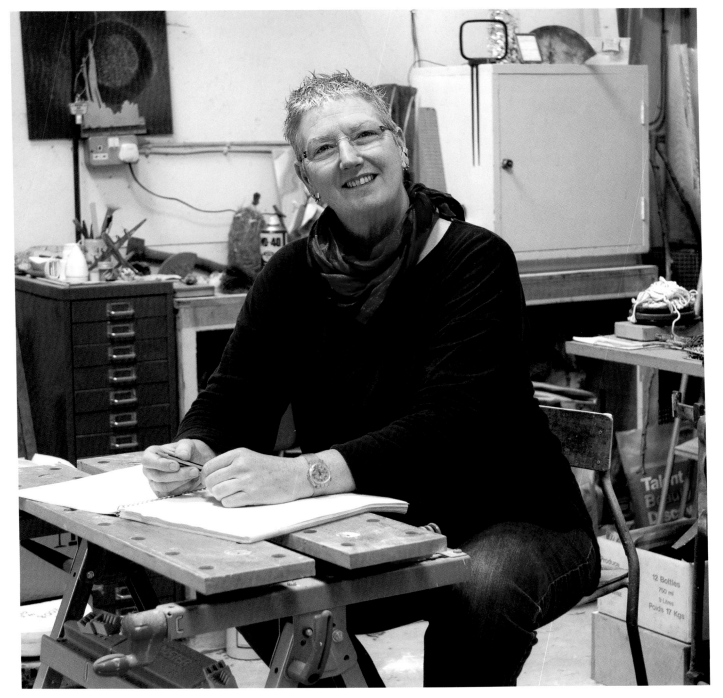

Elected ARA 24 April 1970
Elected RA 9 December 1975

One & One
Bronze
Courtesy Geoffrey Clarke RA
30 x 31cm

Born 28 November 1924
Darley Dale, Derbyshire

Geoffrey Clarke studied at Preston School of
Art from 1941-42 and at Manchester School
of Art from 1942-43 before serving in the RAF
in World War II. He returned to his studies at
Lancaster and Morecambe School of Arts and
Crafts from 1947-48 and the Royal College of
Art 1948-1952. In 1951 he was awarded a
Royal College Travelling Scholarship and the
silver medal at the Milan Triennale. He was
Head of Light Transmission and Projection
Department, Royal College of Art 1968-73.

He has had many solo exhibitions since his
first at Gimpel Fils in 1952 and his work is
widely commissioned both in the UK and
abroad including, among others, Coventry,
Chichester and Lincoln Cathedrals and is held
in The Victoria & Albert Museum, The Tate
Gallery and the Arts Council of Great Britain.

In 1961 he created a free-standing aluminium
sculpture for Sir Basil Spence's home cast
from an expanded-polystyrene form, a method
he still uses in the foundry at his home and
although he has worked in stained glass,
mosaic and print, says that he enjoys casting
the most.

He lives and works in Suffolk.

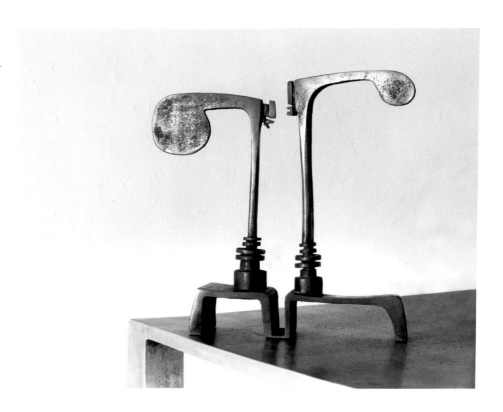

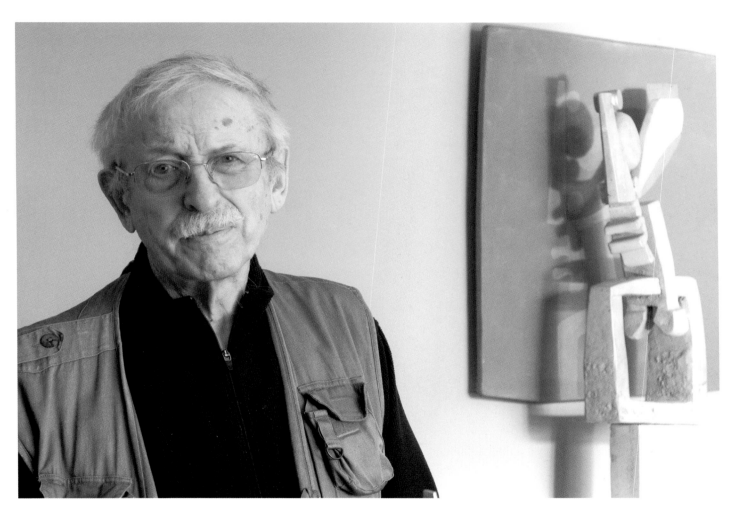

31

ROBERT CLATWORTHY RA

Elected ARA 25th April 1968
Elected RA 26th April 1973

Half Figure
Mixed Media
Courtesy Robert Clatworthy RA
38 cm x 56 cm

Born 31st January 1928
Bridgwater

Robert Clatworthy studied at the West of England College of Art from 1945-46, Chelsea School of Art 1947-49 and the Slade School of Fine Art 1950-51.

He taught at the Royal College of Art and the West of England College of Art in the 1960s-70s, was Governor of St Martin's School of Art from 1970-71 and Head of the Department of Fine Art at the Central School of Art and Design 1971-75.

Robert Clatworthy's first solo exhibition at the Hanover Gallery in 1954 has since been followed by many others in the UK with his work in both The Tate Gallery and the Victoria & Albert Museum.

Public commissions include *Horseman and Eagle* at Charing Cross Hospital and *Bull* at GLC Roehampton in the UK and many others overseas.

Robert Clatworthy is equally at home when working on bronze human and animal figurative works as when working on his many pastel drawings or paintings.

He lives and works in Carmarthenshire.

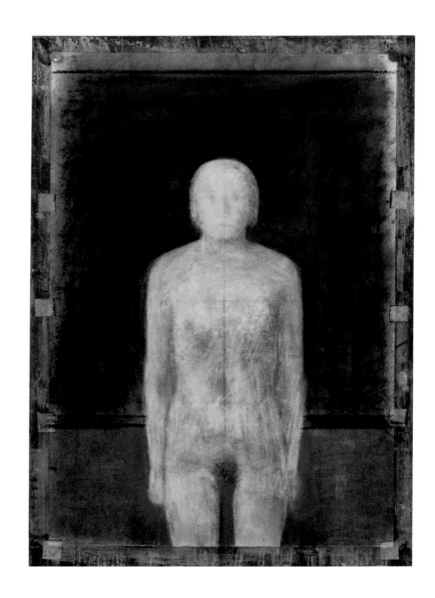

Elected RA 17th March 2003

Law Building, Vienna Economics University
(Competition Winner 2008 artist's impression)
Courtesy Sir Peter Cook RA, Gavin Robotham
and Vienna Economics University

Born 22nd October 1936
Southend on Sea

Peter Cook studied architecture at
Bournemouth College of Art from 1953-58
and then the Architectural Association,
graduating in 1960.

His teaching career commenced in 1963 at
the Architectural Association and he held the
chair from 1984-2002 and was made Life
Professor at the Frankfurt Staedelschule for
raising its architectural profile, a process he
repeated on taking the chair at the UCL
Bartlett School in 1990. In 1970 he became
Director of the Institute of Contemporary Arts
and established and directed *Art Net*
introducing new ideas and people to London,
stimulating discussion on the nature of art
and contemporary culture. From his founder
membership of the visionary *Archigram* group
in the 1960s to his current practice, he has
earned a reputation as an unorthodox
educator, practising architect and a 'maverick
academic'. Peter Cook has won several
international competitions and is currently
working on the design of the 2012 Olympic
Stadium, social housing, a department store
and 'an inflatable structure' in Madrid.

Sir Peter Cook was knighted in 2007.

He lives and works in London.

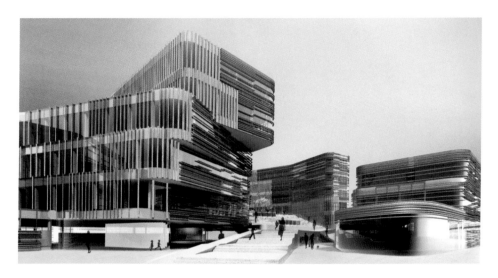

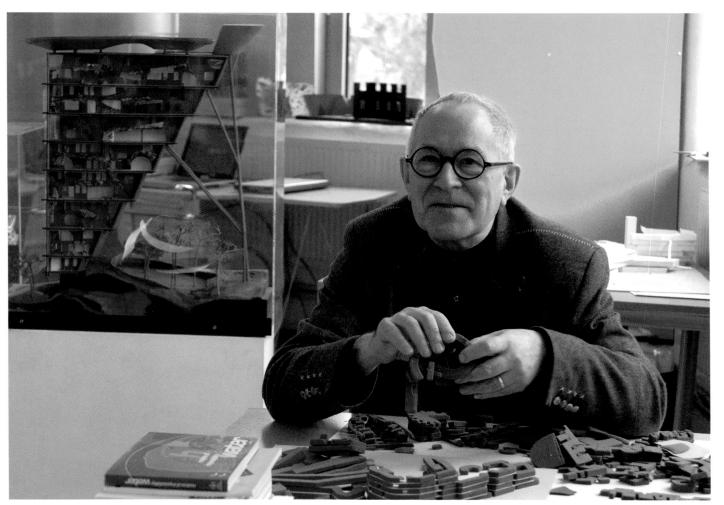

EDWARD CULLINAN CBE RA

Elected RA 26th June 1991

Downland Gridshell Conservation Workshop
Courtesy Edward Cullinan CBE RA and the
Weald and Downland Open Air Museum

Born 17th July 1931
London

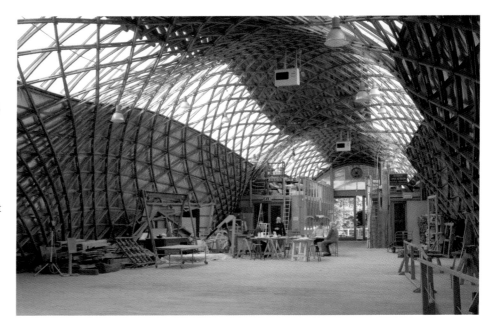

Ted Cullinan commenced his architectural studies at Queens' College Cambridge 1951-54, attended the Architectural Association 1954-56 and University of California, Berkeley, 1956-57. He joined the offices of Denys Lasdun 1960-63 and in 1965 founded his own practice, Edward Cullinan Co-operative, whilst teaching at Cambridge.

His more than 110 projects include the Royal Opera House. Fountains Abbey Visitor Centre and a new Centre for Mathematical Studies at Cambridge University. Amongst his skills is that of marrying English traditional building with new ideas once described by the *Architectural Review* as 'romantic pragmatism'.

He was made CBE in 1987 and received the Prince Philip Designer Prize special commendation in 2005. In October 2007, he was awarded the Royal Gold Medal in recognition of a lifetime's work and which is approved personally by Her Majesty the Queen. Ted Cullinan is the first British architect to receive this honour since 2002, awarded annually to a person or group whose influence on architecture has had a truly international effect. This is only the fourth award made in the past 20 years.

He lives and works in London.

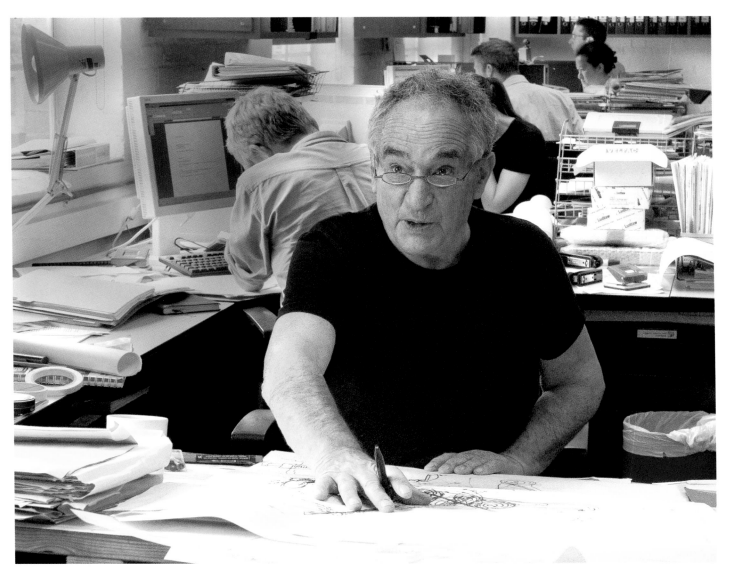

Elected ARA 13th May 1977
Elected RA 18th May 1983

Friends Meeting House, Blackheath
Courtesy Trevor Dannatt RA

Born 15th January1920
London

Trevor Dannatt studied at the Regent Street Polytechnic School of Architecture (now the University of Westminster) 1938-42, after which he went to work in the office of the legendary Maxwell Fry and Jane B Drew. In 1948 he left and joined the London County Council Architect's Department, one of the team who worked on the Royal Festival Hall under the architects Leslie Martin and Peter Moro (1951). He started his own practice in 1952.

Trevor Dannatt's socially-driven modern architecture has spanned a wide variety of use from social project, private home, school and university buildings to the British Embassy complex in Riyadh, Saudi Arabia. These and the earlier project for the Saudi Government, the Conference Centre and Hotel group also in Riyadh, are celebrated in an illuminating book, published in 2008, covering his remarkable sixty-seven years in architecture: *Trevor Dannatt: Works and Words.*

He lives and works in London.

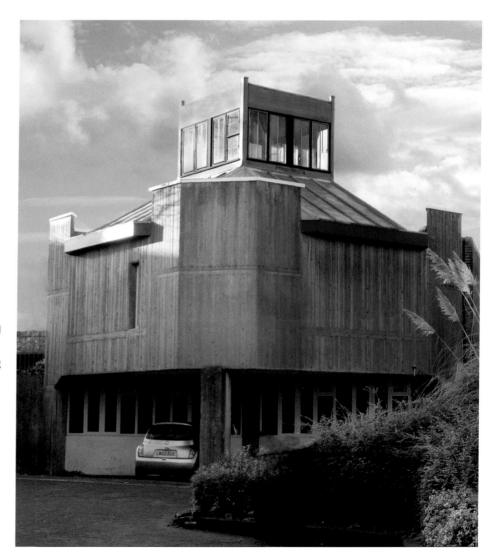

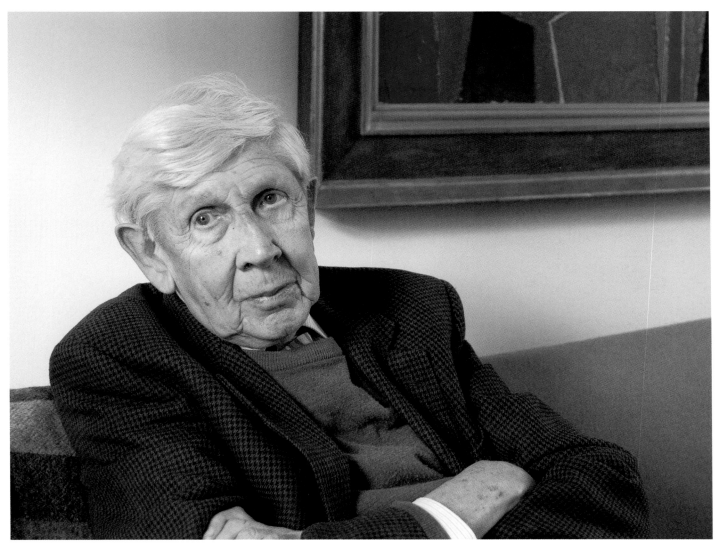

TREVOR DANNATT RA

Elected RA 9th December 2008

The Queen Elizabeth II Great Court,
the British Museum
Courtesy Spencer de Grey CBE RA,
Foster + Partners and the British Museum

Born 7th June 1944
Farnham Surrey

Spencer de Grey studied architecture at Cambridge University (1963-69) after which he worked for the London Borough of Merton on one of the first middle schools in England.

Joining Foster Associates in 1973, he continued his interest in education, with the Palmerston Special School in Liverpool, but in 1979 set up the practice's office in Hong Kong to work on the Hong Kong & Shanghai Bank before returning to London to take charge of the new third London airport at Stansted Airport (1981-91).

He became a partner in 1991 and was made a CBE in 1997. He has overseen an impressive list of widely-varied projects including the Law Faculty at Cambridge, the Great Court at the British Museum, the Boston Museum of Fine Arts, HM Treasury in Whitehall, the rebuilding of Dresden Railway station, together with The Sage Gateshead and the new Opera house in Dallas, music being one of his great passions in life. He is now Joint Head of Design at Foster + Partners.

He lives and works in London.

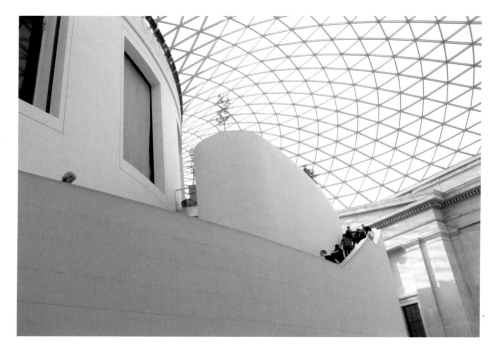

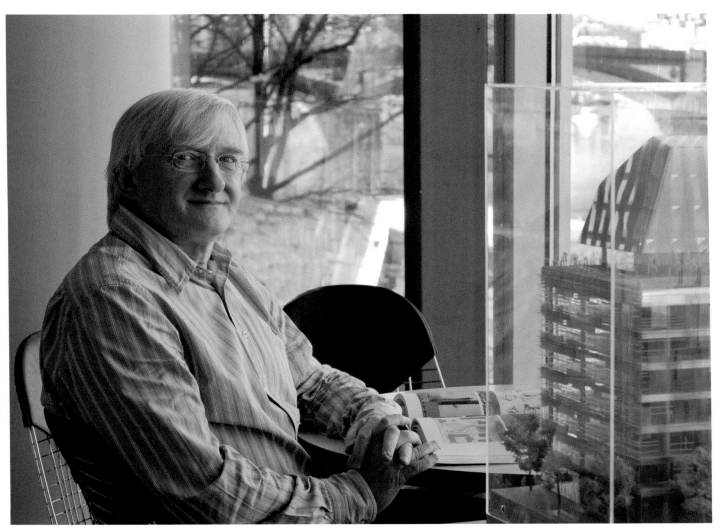

Elected RA 21st May 1998

You, 1998
Wood, cloth, epoxy resin
Courtesy Galerie Ropac, Paris and Richard
Deacon CBE RA
130cm x 143cm x 35cm

Born 15th August 1949
Bangor, N. Wales

Richard Deacon studied at Somerset College of Art, Taunton 1968-69, St Martin's School of Art 1969-72, the Royal College of Art 1974-77 and part-time at Chelsea School of Art in 1978.

Since 1977 he has taught sculpture at art schools in the UK, Holland, Austria and Israel both as Visiting Lecturer and Professor, advisor to Rijksakademie van Beelden Kinsten in Amsterdam and since 1999 has been Professor at Ecole Nationale Supérieure des Beaux Arts in Paris.

His first solo exhibition at The Gallery in Brixton in 1978 has been followed by many others throughout the world.

Richard Deacon has won prestigious awards including the Turner Prize in 1987, the Robert Jakobsen Prize, and in 1997 he was awarded Chevalier des Arts et des Lettres and made CBE in 1999.

His works range from those on a domestic scale to a piece over 24 metres in length in a range of materials which he fabricates into shapes combining the submissive foundations of human life with the precisely engineered form.

He lives and works in London.

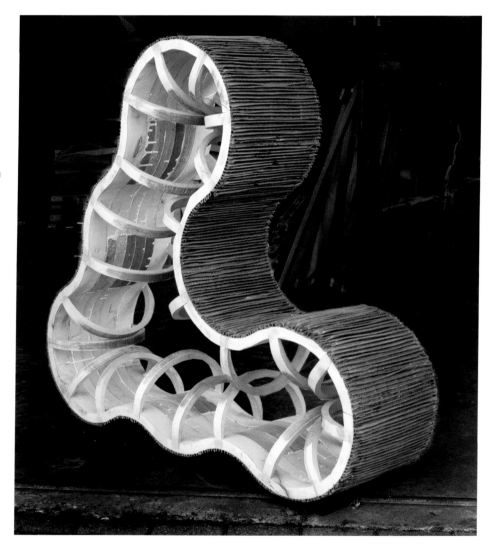

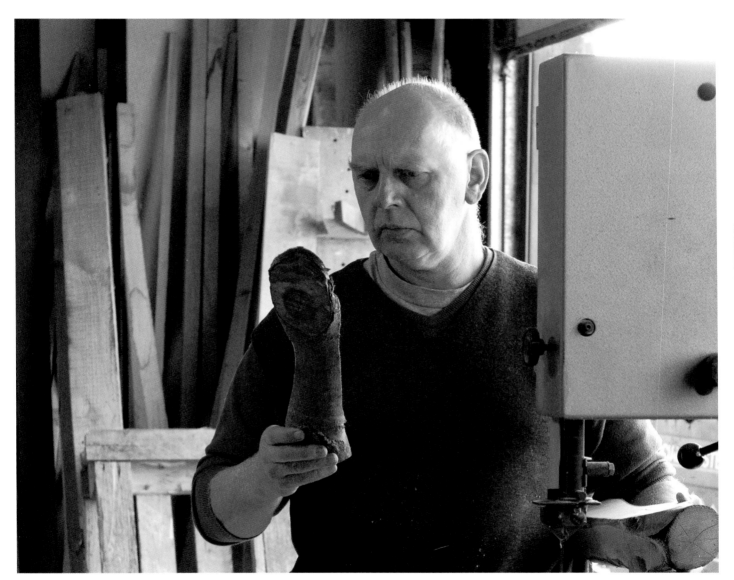

Elected ARA 9th May 1979
Elected RA 14th November 1985

The IBM Building, Johannesburg
Courtesy Sir Philip Dowson CBE PPRA and
Arup Associates

Born 16th August 1924
Johannesburg

Sir Philip Dowson went up to University College, Oxford to read Mathematics in 1942 and served in the Royal Navy from 1943-47. After demobilisation he studied Fine Art at Clare College, Cambridge, 1947-50, followed by study at the Architectural Association.

In 1953 he joined Sir Ove Arup and in 1963 became the founding architectural partner of Arup Associates Architects & Engineers becoming a Senior Partner in the Ove Arup Partnership in 1969. During his long career he has been able uniquely to develop his skills to bring together and integrate the arts and disciplines of science, architecture and design in a manner for which Arup's became legendary.

In 1969 he was made CBE. Knighted in 1980 he was awarded the Royal Gold Medal for Architecture in 1981. He was President of the Royal Academy of Arts from 1993-99.

Although he retired as a Senior Partner of the Ove Arup Partnership in 1990 he has retained an active interest in a variety of related fields remaining a consultant.

He lives and works in London and his family home in Norfolk.

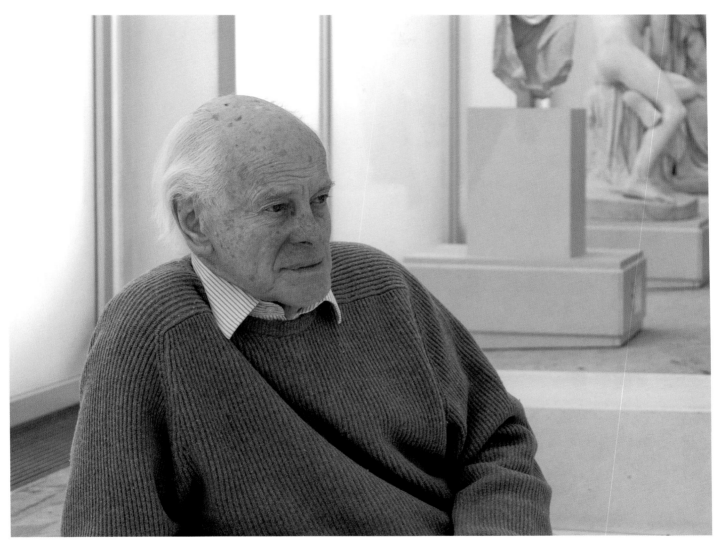

Elected ARA 30th May 1990
Elected RA 26th June 1991

Cross Wind 2007
Mixed media on paper
Courtesy Kenneth Draper RA and
Mr and Mrs J Dobson
36 cm x 41 cm

Born 19th February 1944
Sheffield

Ken Draper studied painting at Chesterfield College of Art 1959-62 and Kingston School of Art 1962-65 followed by studies in Sculpture at the Royal College of Art 1965-68.

He taught at Goldsmiths College School of Art and Camberwell School of Arts & Crafts and in 1980 was elected to the faculty of the British School in Rome.

Ken Draper held his first solo exhibition in 1969 at the Redfern Gallery, London followed by many others throughout the UK, the USA and Europe during which time he has also received a large number of commissions for public, corporate and private collections. The energy of colour has always played a major role in his work combined with the exploration of spatial ambiguity and paradox. This has never been more defined than in his relief assemblages made over the last few years.

He says 'my work always creates a dialogue between sculpture, painting and drawing. The explosions in my new work on paper respond mainly to the piercing beauty and ravaged landscape of my home on the Spanish island of Menorca'

He lives and works in Menorca.

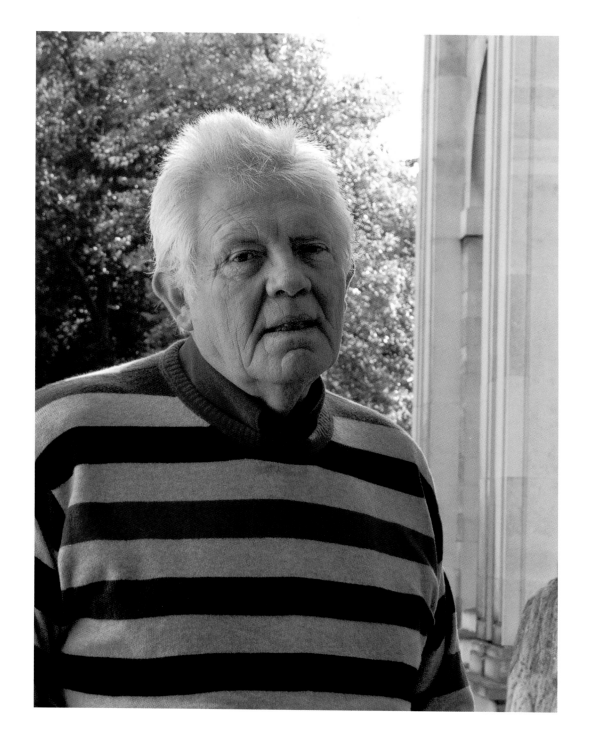

Elected ARA 27th May 1987
Elected RA 26th June 1991

Moon Gold Hare 2008
Bronze and gilded bronze
Courtesy Barry Flanagan RA and
Waddington Galleries
162.9 x 38.5 x 145.8 cm

Born 11th January 1941
Prestatyn, Wales

Barry Flanagan studied at Birmingham
College of Arts & Crafts 1957-58 and the
St Martin's School of Art 1964-66. He taught
at both the St Martin's School of Art and the
Central School of Art & Crafts in London
1967-71.

His first solo exhibition in 1966 was at the
Rowan Gallery in London where he continued
to exhibit throughout the 1970s before
showing at the Waddington Galleries who
represent him.

Barry's international reputation was rapidly
established in 1968 followed by solo shows
worldwide from New York to the Fuji Television
Gallery in Tokyo including his representing
Britain at the Venice Biennale in 1982. His
work is held internationally in more than 40
public collections.

At the opening of his exhibition in the Dublin
Museum of Modern Art in 2006 J P Donleavy
said that he was 'also a deadly serious man
who not only achieves but gives us a bit of
public joy'.

He lives and works in Dublin.

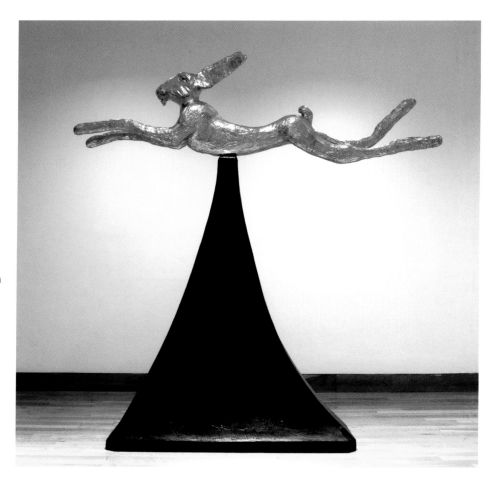

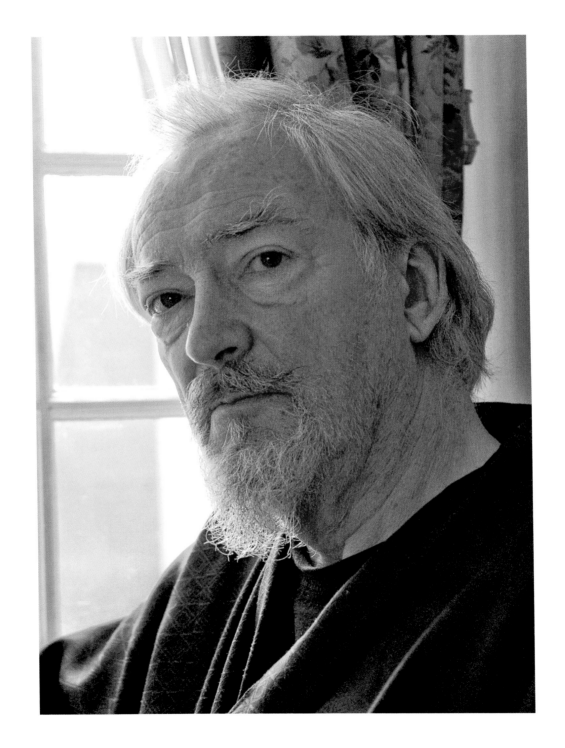

Elected RA 26th June 1961

Millennium Bridge
Courtesy Lord Foster OM RA

Born 1st June 1935
Manchester

Born in Manchester, Norman Foster was sent to a private and grammar school and studied commercial law while working in local government before doing National Service in the Royal Air Force. Winning a fellowship at Yale, after graduating from Manchester University School of Architecture, brought him under influences upon which he has built his practice. A four-year partnership 'Team 4', with Richard Rogers, Wendy Cheesman and her sister Georgina Wolton, preceded the establishment of Foster Associates in 1967, now known as Foster + Partners.

The practice has won more than 500 awards and citations for excellence, numerous national and international competitions and been responsible for more than 140 major projects.

Knighted in 1990, in 1997 made a member of the Order of Merit, he was made a Life Peer in 1999.

Lord Foster lives in Switzerland and Spain and works in the Foster project offices around the world.

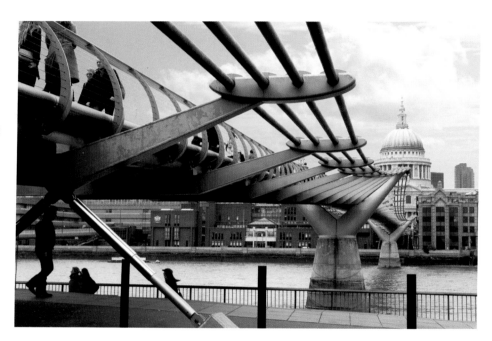

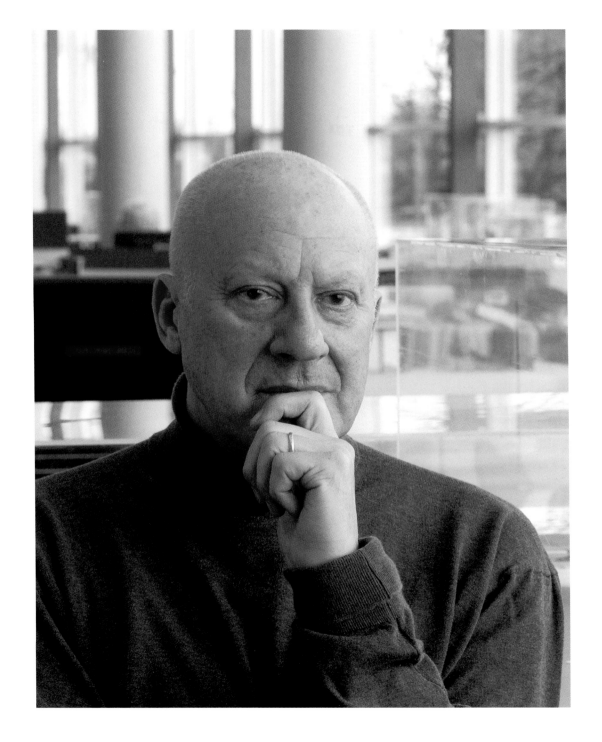

Elected RA 23rd May 2003

Drift
Courtesy Antony Gormley OBE RA

Born 30th August 1950
London

On gaining a degree in archeology, anthropology and the history of art at Trinity College, Cambridge in 1971 he spent 3 years in India and Sri Lanka studying Buddhist meditation. His first works on returning were plaster-soaked sheets laid over the bodies of friends forming simple abstract yet specific shells. Between 1975-79 he studied at the Central School of Art, Goldsmiths School of Art and the Slade School of Fine Art.

His early 1980's three-piece lead works were the first in which he used his own body 'trying to map out its phenomenology and find a new way of evoking it as a thing a site of transformation and an axis of physical and spatial experience'.

His massive, well-known 'Angel of the North' and 100 figures forming 'Another Place' over the Merseyside foreshore, are but two of more than 800 projects made in the past 35 years.

He lives and works in London.

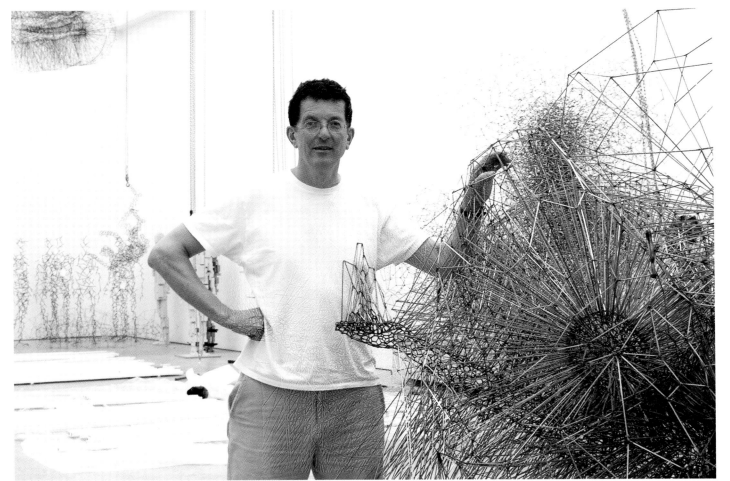

Elected RA 5th December 2001

Public Convenience,
Westbourne Grove, London
Courtesy Piers Gough CBE RA

Born 24th April 1946
Brighton

Piers Gough studied at the Architectual Association's School of Architecture 1965-71 with partners Nicholas Campbell, Rex Wilkinson and former partner Roger Zogolovitch. CZWG Architects was set up while they were still students, an arrangement that they formalised in 1975. In 2006 they took on a further eight additional partners and re-formed into an LLP.

Piers radiates a sense of excitement and a joie de vivre which is reflected in his innovative and often flamboyant designs.

These range from the transformation of existing buildings in both function and appearance, masterplanning many mixed-use schemes such as Fulham Island, the Crown Street Masterplan in Gorbals and the Arsenal masterplan around the stadium, down to a public convenience in central London, attracting many international tourists.

His principal buildings include: China Wharf and Westferry Studios in London's Docklands; Various buildings at Bryanston and Uppingham Schools; the Street-Porter house in London; Summer Street Lofts, Bankside Lofts, Bankside Studios, the Glass Building and South Central all in London.

He lives and works in London.

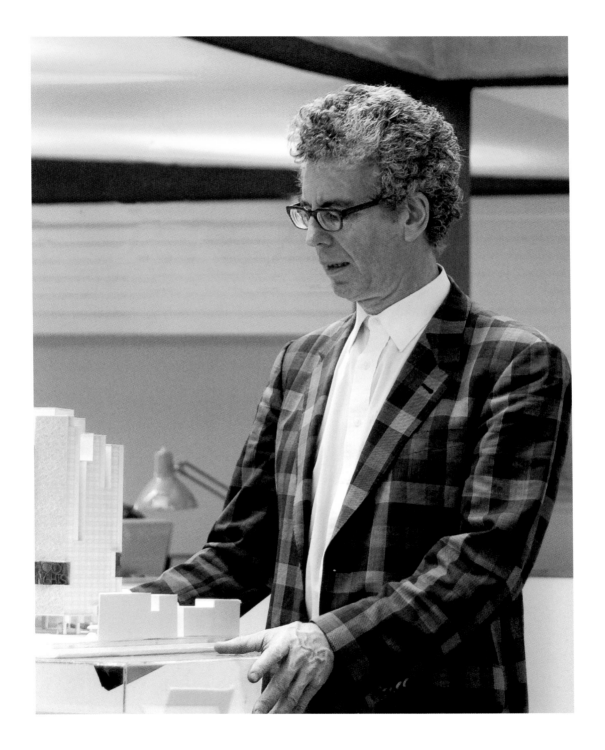

Elected RA 23rd May 1994
Elected President in 2004

Waterloo International Terminal
Courtesy Grimshaw Architects

Born 9th October 1939
Hove

Sir Nicholas Grimshaw studied at Edinburgh College of Art & Architecture 1959-62. He won scholarships, in 1962 to attend the Architectural Association School of Architecture, 1963 to Sweden, 1964 to the USA, before graduating in 1965. He established his own practice, Nicholas Grimshaw & Partners, in 1980.

He was made a CBE in 1993, the same year that his International Terminal at Waterloo Station was opened by Her Majesty the Queen. This design won him awards in the UK and Europe. In 1999 he was elected President of the Architectural Association and in 2000 his practice became one of the first to develop software able to assess Environmentally Viable Architecture. His Eden Project was opened in 2001 and he was knighted in 2002.

Nicholas Grimshaw became President of the Royal Academy in 2004 and set about a thorough review of its laws and administration. All these changes were enthusiastically agreed by the RAs in 2007 and approved by the Queen in 2008.

He lives and works in London.

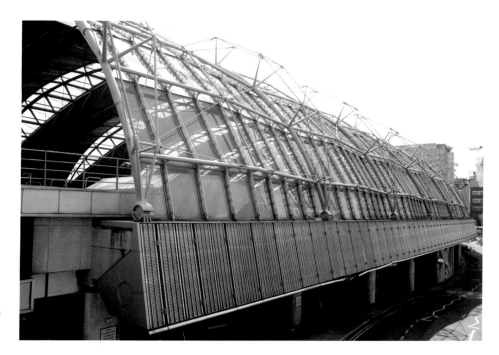

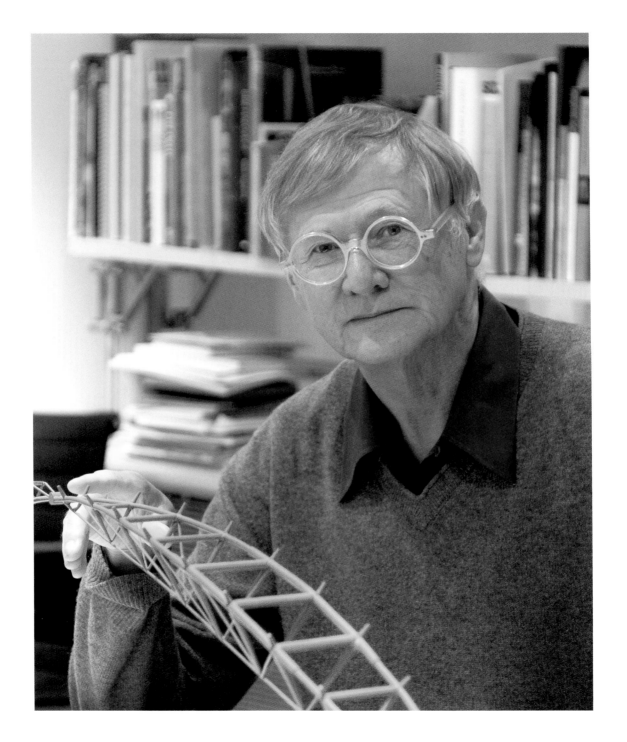

Elected RA 17th March 2003

Echo 2008
Courtesy Nigel Hall RA

Born 30th August 1943
Bristol

Nigel Hall studied at the West of England College of Art, Bristol from 1960-64 and the Royal College of Art 1964-67.

Winning a Harkness Fellowship in 1967 took him to the USA for two years. This award offers full funding and no agenda or obligations other than a requirement to register at a University. Nigel registered at UCLA and established his studio in Los Angeles from which he made frequent walking trips in the Mojave Desert becoming aware of the dimensions, relationships and importance of space which has played a pivotal role in his work ever since.

His abstract works express his interest in seeking the junctions between light, shade and edge – the relationships of space to form in which to express and emphasise his spatial awareness. Nigel's time is divided between his sculptures and drawings which, now mainly in charcoal and gouache, define the same form of vibrant exciting shapes found in his sculptures.

His work is in around 70 public, over 50 corporate and numerous private collections throughout the world.

He lives and works in London.

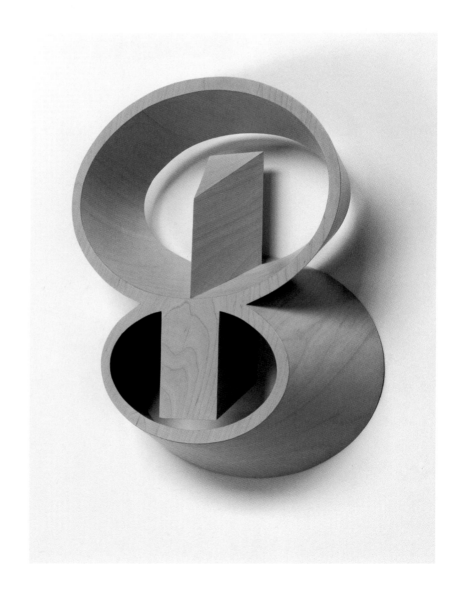

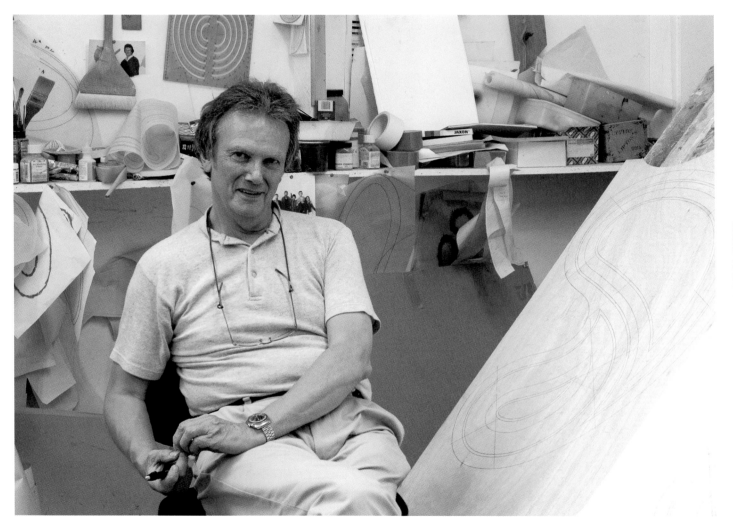

Elected RA 28th May 1992

The Forum, Norwich
Courtesy Sir Michael Hopkins CBE RA and
The Forum Trust

Born 7th May 1935
Bournemouth

Michael Hopkins studied at the Architectural Association 1959-64. With his wife Patricia he formed his own practice in 1976 with work characterised by sophisticated steel and glass in the genre of the radical modernists. Since the 1980s contributed to the debate about the relationship between Tradition and Modernity, and has presented progress as a continuum with intelligent integration of traditional materials into the contemporary designs afforded by new technologies.

His practice received the 2008 *Building Magazine* Sustainable Architect of the Year Award for a building which met or exceeded previous targets and ethical concerns. The practice has won more than 150 Awards. Examples include the Mound Stand at Lords, The Queen's Building, Emmanuel College, Cambridge, the Evelina Children's Hospital, Glyndebourne Opera House and the Lawn Tennis Association National Tennis Centre.

With his wife, he won the RIBA Gold Medal in 1994, the year when he also won The Prince Philip Prize for Designer of the Year. He was made a CBE in 1989 and knighted in 1995.

He lives and works in London.

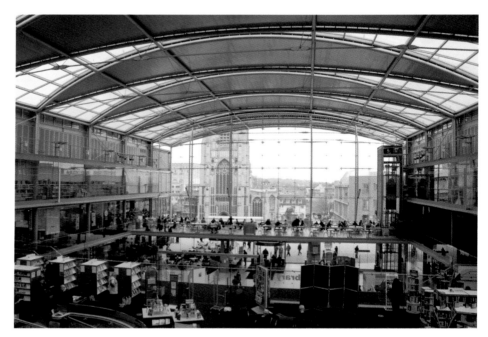

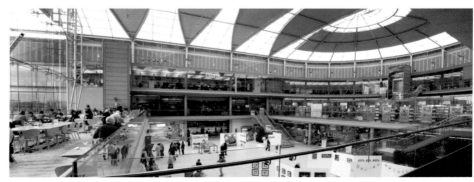

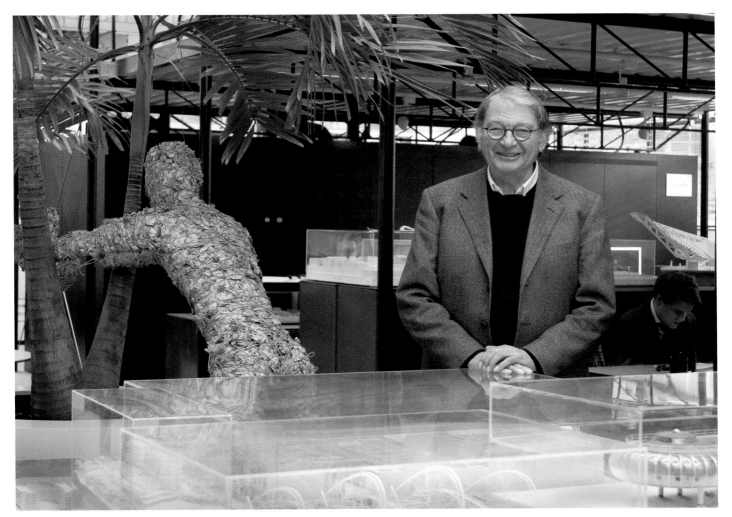

Elected RA 19th May 1997

Transport Interchange Canada Water, London
Courtesy Eva Jiricna Architects
and Transport for London

Born 3rd March 1939
Zlin, Czechoslavakia

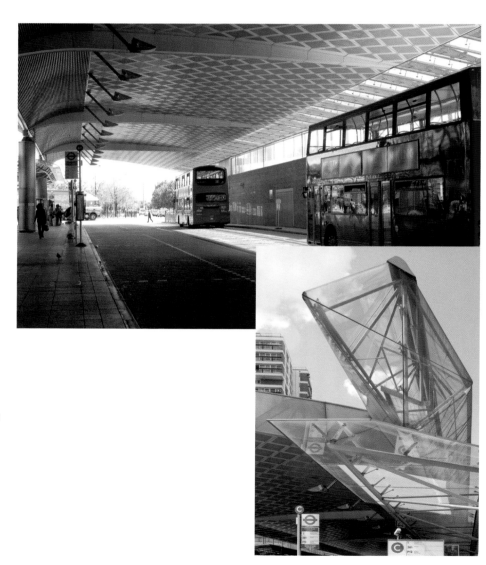

Eva Jiricna studied architecture at the Technical University of Prague 1956-62 and took a Postgraduate Degree at the Prague Academy of Fine Arts 1963-67. Unable to return to Czechoslovakia after the invasion of 1968, she remained in London obtaining a Diploma from the Royal Institute of British Architects in 1973.

During 1969-82 she took leading roles in the teams responsible for Brighton Marina and the interior of the Lloyds of London building before starting her own practice in 1982.

Eva has received a number of awards, Honorary Fellowships, Doctorates and Chairs in a number of UK and Czech Universities and was a made a CBE in 1994.

Her numerous minutely detailed designs encompass a large variety of applications where she uses glass and steel to create light, transparent, innovative structures ranging from well-known luxury retail interiors, through the elegant transport interchange at Canada Water to the most delicate pedestrian bridge at Ostrava in the Czech Republic.

Eva Jiricna lives and works in London.

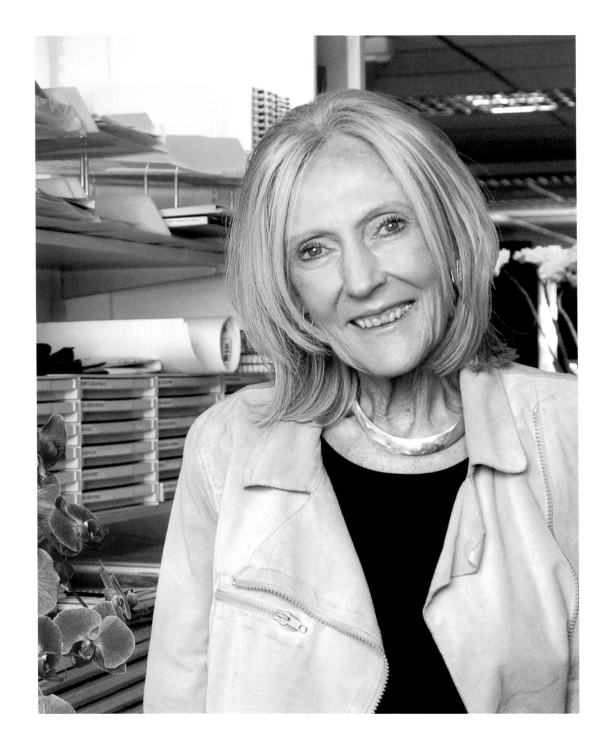

Elected ARA 12th May 1977
Elected RA 4th May 1988

Tunis Rak
Painted Foam PVC
Courtesy Phillip King CBE PPRA
130 x 210 x 22 cm

Born 1st May 1934
Tunis

Phillip King was born and brought up in Tunis. At the age of twenty he came to England to study modern languages at Cambridge from 1954-57 where he became interested in sculpture and on leaving studied it at St Martin's School of Art 1957-58 under Sir Anthony Caro. He taught at St Martin's for a year following which he became assistant to Henry Moore.

His first solo exhibition in 1964 at the Rowan Gallery was followed by numerous others in Europe and overseas including Forte de Belvedere, Florence where he was only the second English sculptor to be so honoured, the first being Henry Moore. He has work in more than 40 Public collections in Europe, USA, Japan and Australia.

Phillip King has always worked in a variety of materials and in a wide range of form and colour from small to some very large works. He has taught throughout his career holding chairs of sculpture at, among others, the Royal College of Art, The Royal Academy and Hochschule der Kunste, Berlin. In 1968 he represented Britain at the Venice Biennale. He will be getting a 'Life-Time Achievement Award' from the International Sculpture Centre in 2010.

He lives and works in London.

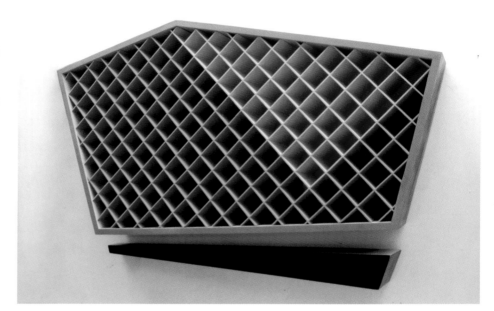

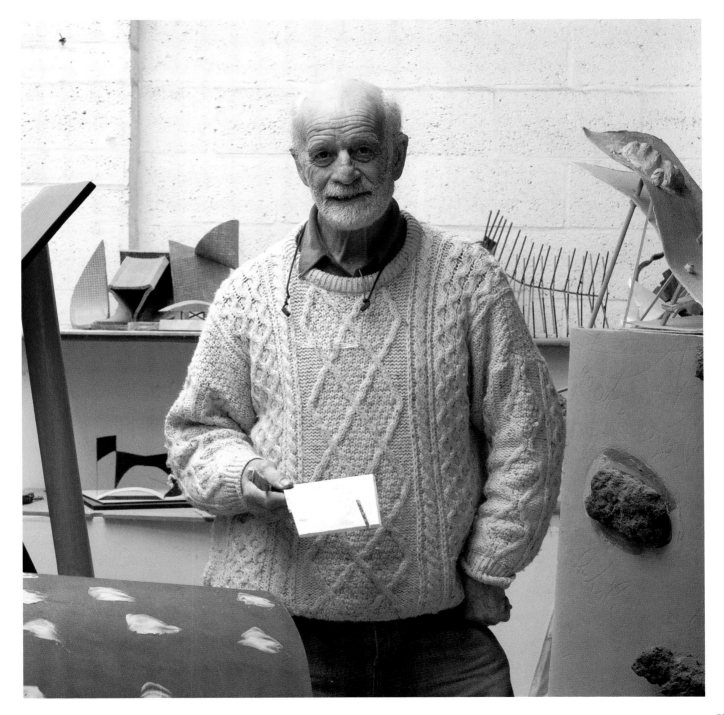

Elected ARA 23rd April 1970
Elected RA 12th February 1974

Scylla & Charybdis
Palinated Brass & Nylon
Courtesy Bryan Kneale RA
43 x 20.5 x 12 cm

Born 19th June 1930
Douglas, Isle of Man

Bryan Kneale began his studies at the Douglas School of Art in 1947 and from 1948-52 went to the Royal Academy Schools, winning the Rome Scholarship in Painting, working in Rome 1949-51. By 1960 he no longer worked as a painter devoting himself entirely to sculpture, working directly in steel. He became Tutor at the Royal College of Art, Head of Sculpture 1985-90 and Professor of Drawing, 1990-95.

On his election to the Royal Academy in 1970 he created a major exhibition of British Contemporary Sculpture which many regard as a turning point in sculptors' attitudes to the RA. Later, in 1977, he was chosen to direct a major exhibition of sculpture in Battersea Park celebrating the work of living sculptors during the Silver Jubilee of the Queen's reign.

He first showed his work in solo exhibition at the Redfern Gallery in 1954 since when it has been seen in the UK and Europe represented and collected as widely afield as the USA, Australia and South America.

His sometimes very large, intricately interlocking or juxtaposed works, link in almost abstract ways.

He lives and works in London.

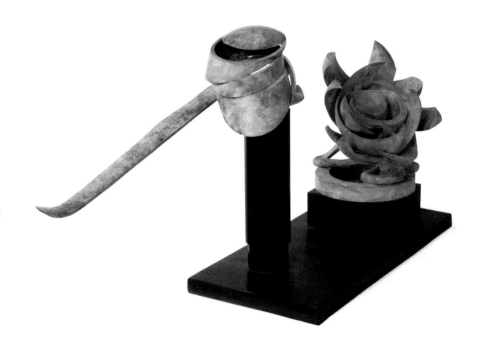

Elected RA 26th June 1991

Main Interior and Espresso Bar/Coffee Shop
John Lewis, Kingston on Thames
Courtesy Paul Koralek CBE RA and
John Lewis Partnership

Born 7th April 1933
Vienna

Paul Koralek came to the UK aged five in 1938 when his family fled from the Nazis. He spent a year immersed in French language and culture at the Sorbonne before studying at the Architectural Association in 1951 where he met Peter Ahrends and Richard Burton with whom he was to form the Ahrends Burton and Koralek partnership in 1961.

After winning an international competition for the design of a new library building for Trinity College, Dublin, he designed the 15,000 m² new Arts Faculty Building for TCD completed in 1979. This was followed by a refurbishment and extension of the School of Dental Sciences, also in TDC, a complex and challenging project undertaken without interruption to the operational activities of 264 students and 2500 patients per week. This blending of new and old has been one of the distinguishing characteristics of the practice which works in many fields including public buildings, education, healthcare, commercial and residential buildings in the UK, Ireland and overseas winning numerous awards for design and technical achievement.

Paul Koralek is Chairman of the South East Regional Design Panel.
He lives and works in London.

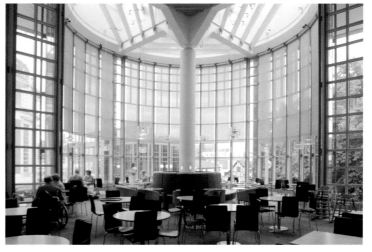

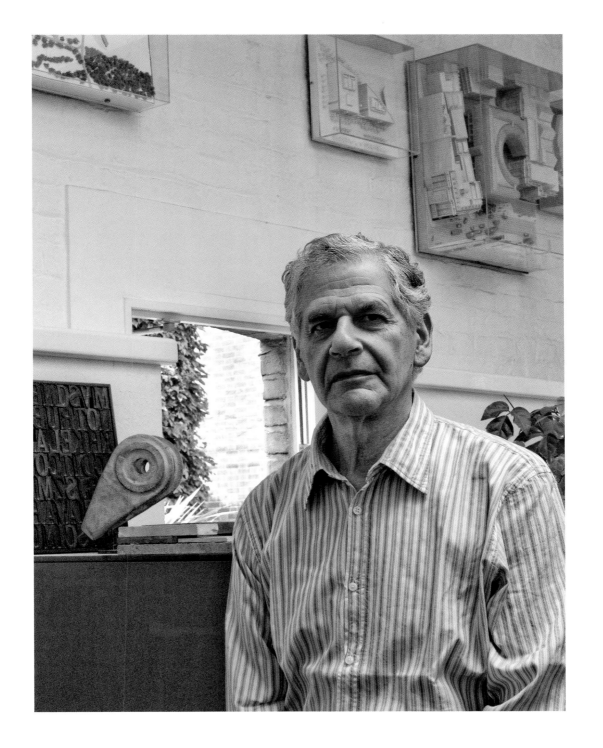

Elected RA 5th December 2001

'Walking Music' Text work
Courtesy Richard Long RA

Born 2nd June 1945
Bristol

Richard Long studied at the West of England College of Art 1962-65 and St Martin's School of Art 1966-67. His work has since been seen in 272 solo exhibitions in the UK, Europe, the USA, Japan, Australia and Iceland, among the countries in which it is also held in more than 30 public collections.

His is a unique form of art – 'Land Art' which emerged shortly after he left art school which he presents to the viewer in differing forms in photographs, mud works, maps and text works. He stresses that the meaning of his work lies in these records of his ideas rather than in the representation of a particular landscape. Richard uses 'walking' as his medium for making his works – a photograph of a trail left in the grass after his walking back and forth in a straight line – using stones as markers of time or distance in the landscape, or making lines and circles of stones in remote parts of the world.

He represented Great Britain in the Venice Biennale in 1976. His prizes include the Turner Prize (London 1989), Chevalier de L'ordre des Arts et des Lettres (Paris1990) and the Wilhelm Lehmbruck (Germany 1995).

He lives in the West Country and works in the landscape.

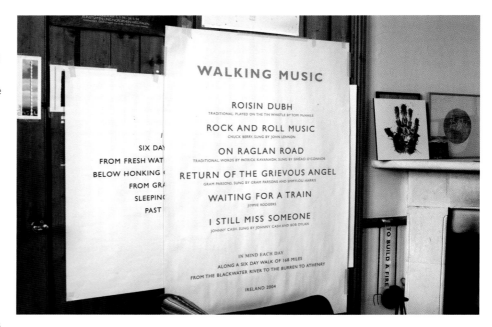

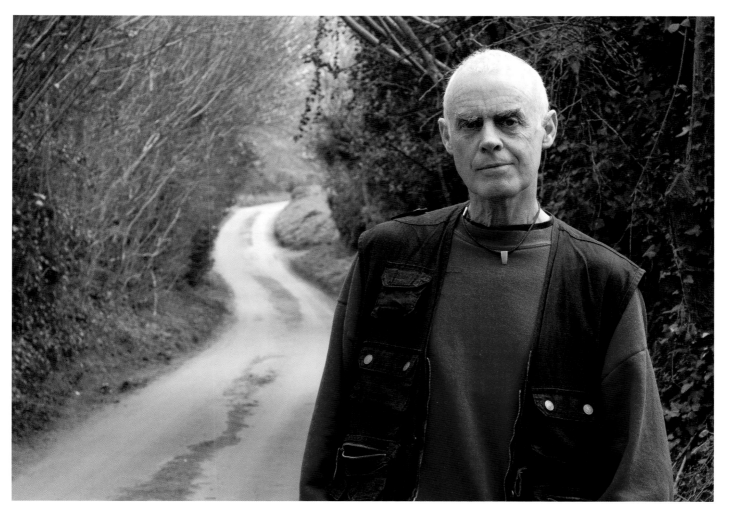

Elected RA 4th May 1993

Southwark Station, intermediate concourse
Courtesy of Sir Richard MacCormac CBE
PPRIBA RA & Transport for London

Born 3rd September 1938
London

Richard MacCormac studied architecture at Cambridge. He established MJP Architects in 1972, Notable building projects include Cable & Wireless College, Coventry; Garden Quadrangle, St John's College, Oxford; Ruskin Library, Lancaster University; the Wellcome Wing at the Science Museum and Southwark Station, Jubilee Line Extension.

Richard has taught and lectured widely, published articles on urban design and architectural theory and is regularly invited to be an assessor of architectural competitions and design awards. He is a Fellow of the Royal Society of Arts and a past commissioner for English Heritage. He served as President of the Royal Institute of British Architects from 1991 to 1993. In 1994, Richard was made a CBE, and knighted in 2001. He is chairman of the Royal Academy Forum, and was chairman of the Royal Academy Architecture Committee from 1998 to 2008. He is also a trustee of Sir John Soane's Museum. Masterplanning projects include the expansion of Cambridge University, and the Phoenix Initiative, a project to regenerate Coventry City Centre which was shortlisted for the Stirling Prize in 2004.

He lives and works in London.

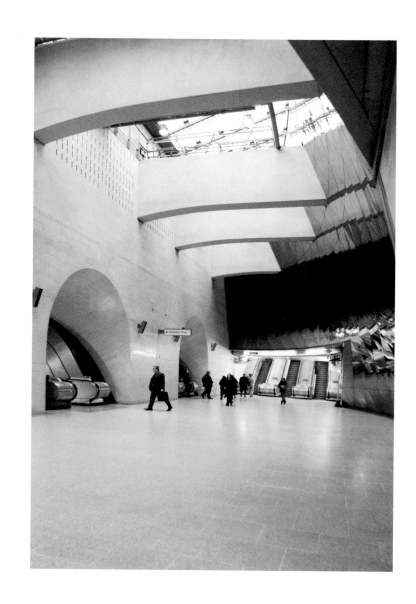

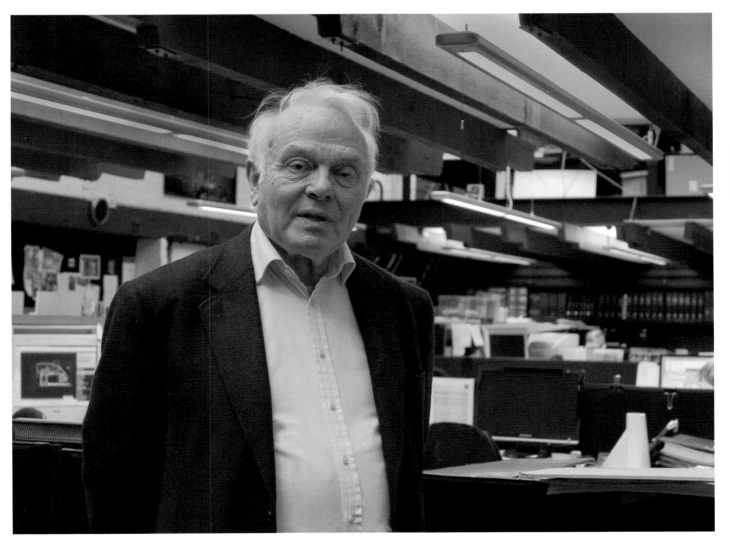

DAVID MACH RA

Elected RA 21st May 1998

Walk like an Egyptian
Postcard Collage 2008
Courtesy David Mach RA
1.8 m²

Born 18th March 1956
Methil, Fife

David Mach studied at the Duncan of Jordanstone College of Art, Dundee 1974-79 and the Royal College of Art 1979-82 and has been part time lecturer, Kingston University 1982-93, Contemporary Art Summer School Kitakyushu,Japan, 1987-81.

His first solo exhibition at the Lisson Gallery in 1982 was followed by an incredible number of shows in almost every country in the world. For example in 1989 he lists no less than 12 exhibitions in 10 different cities from the USA and Europe to Australia.

No slave to the potter's wheel or the sculptor's armature and plaster, David Mach works at a hectic pace experimenting with new ideas and techniques from hundreds of wire spikes extending from figurative forms in his 'Coathangers' series, through human and animal figures whose surfaces are formed by multiple 'Matchheads' to hundreds of postcards onto a wide variety of other collages which he claims has now become a relentless activity which feeds all of his work through which he can explore new proposals for sculpture and installation.

He lives and works in London.

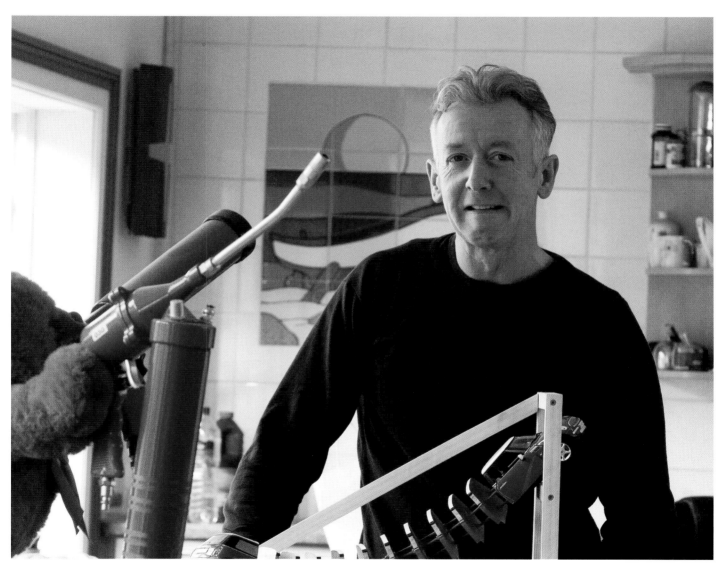

Elected RA 22nd May 1995

Tidal Enclosure 2008
Granite
Weston-super-Mare
Courtesy John Maine RA

Born 31st October 1942
Bristol

John Maine studied at the West of England College of Art 1960-64 and the Royal College of Art 1964-67. He held his first solo exhibition at the Serpentine Gallery in 1972 and was the first Fellow of the Yorkshire Sculpture Park in 1979. His work has won many prizes and awards, and is held in more than 30 public collections in the UK, Ireland, India, Australia, and Japan.

Stone is John Maine's preferred material, from his early works in Portland stone and Carrara marble to the granite of his unconventional War Memorial at Islington Green, and his architectural sculptures at the Royal Bank of Scotland and Standard Life House in Edinburgh.

Maine frequently works on large scale outdoor projects such as 'Arena' on the South Bank, 'Earthworks' at Chesil Beach, Dorset and 'Place of Origin' at Kemnay quarry Aberdeenshire. Having completed his sculpture sequence at Howden Minster in Yorkshire, he created 'Observatory' in situ at Hue, Vietnam in 2008. Most recently he is combining sculpture and sea defence on the foreshore at Weston-super-Mare commissioned by North Somerset Council.

He lives in Wiltshire.

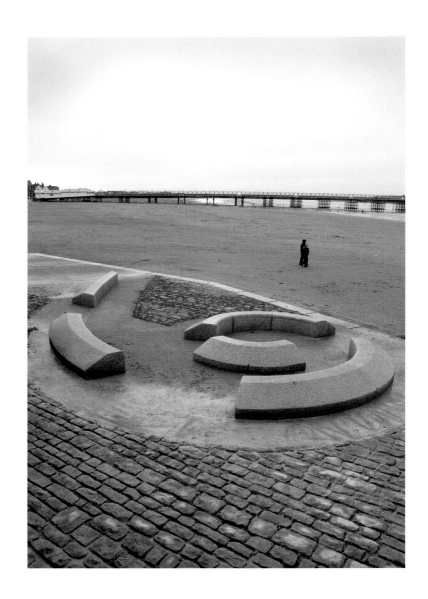

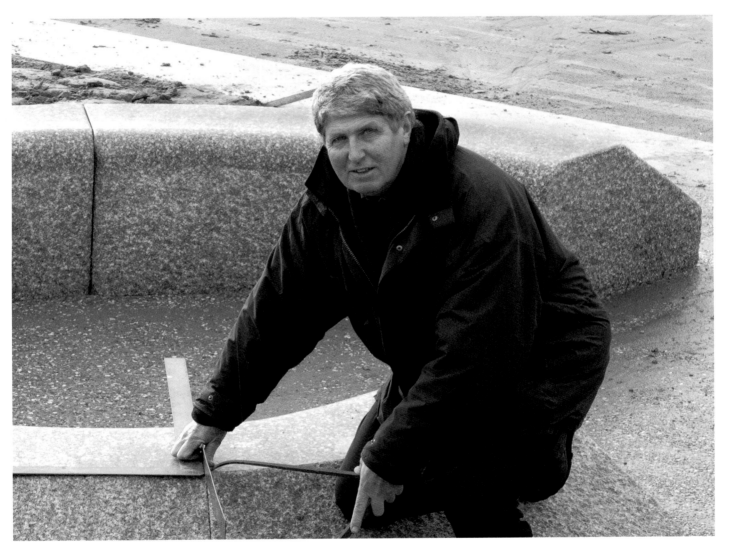

Elected ARA 30th April 1976
Elected RA 9th May 1979

The National Motor Museum Beaulieu
Courtesy Leonard Manasseh OBE RA
PPRWA and the National Motor Museum,
Beaulieu

Born 21st May 1916
Singapore

Leonard Manasseh served in the Fleet Air Arm during WWII and started his architectural career in Local Government. His design for a luxury restaurant on a glass floor over the Thames for the 1951 Festival of Britain won him a place in the group who initiated Post-War Modern British architecture but when spending was cut back he was offered the design of the toilets instead! Accepting enabled him both to design a glass-floored bar area over the river and start his own practice. He has published numerous articles and won many awards for his devotion to the modernist principles incorporated into projects ranging from private houses to schools and courts of law. Remaining one of his favourites is his partnership's seventy-acre 1972 Beaulieu complex with, as its central feature, the National Motor Museum.

Leonard Manasseh taught at the Architectural Association during the 1950s becoming its President from 1960 to 1965. He was made an OBE in 1982 and became President of the RWA in 1989.

He is an accomplished painter exhibiting both in and outside the Royal Academy of Arts.

He lives and works in London.

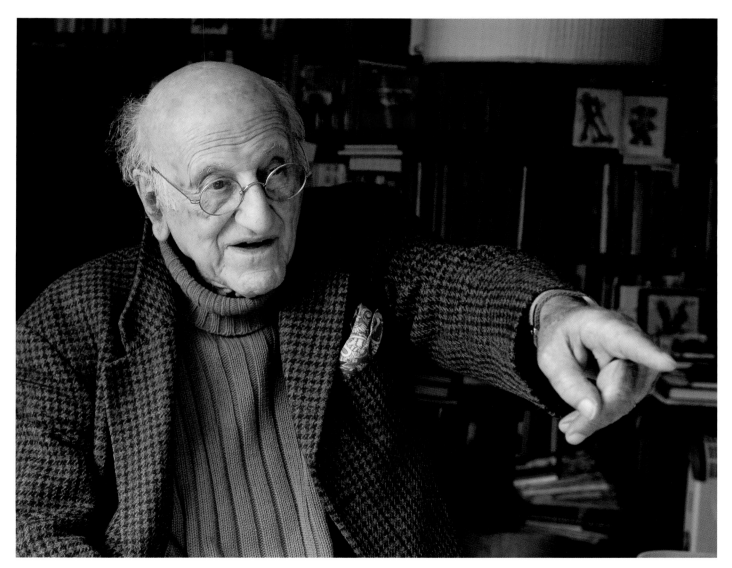

Elected RA 8th November 1994

Partial Atrium Hilton Hotel London
Heathrow Airport
Courtesy The Manser Practice and Hilton
Hotels

Born 23rd March 1929
London

Michael Manser studied architecture at
Regent Street Polytechnic qualifying in 1954
before National Service in the role of acting
Staff Captain Royal Engineers.

He set up his own practice in 1961 with a
series of houses blending established
materials with modernist use of large glass
and steel cubic areas, an approach he carried
into the larger commercial projects for which
he subsequently became responsible. He
became an active spokesman for modernism
in the 1980s including the influential period of
his presidency of the Royal Institute of British
Architects (1983-85). Michael Manser was
made CBE in 1993.

In 2001 an RIBA Manser Medal was
established which is awarded to a UK
architect for the best one-off house or major
extension built in the UK during the past year.

He lives and works in London.

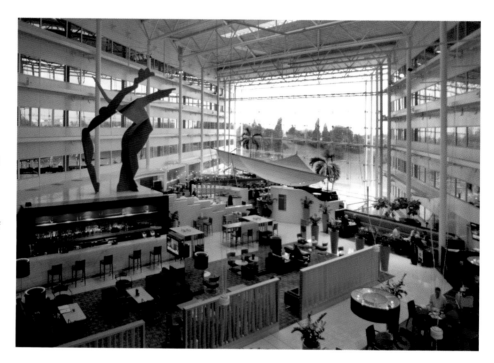

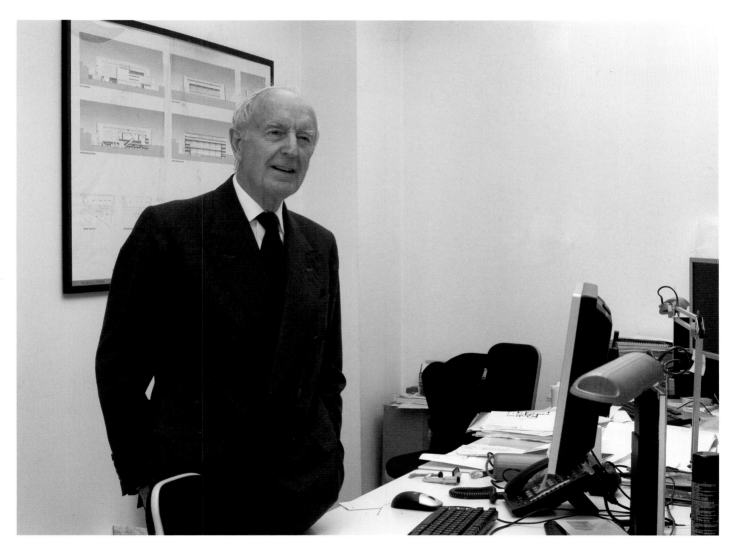

Elected RA 26th May 1999

Crag and Cave 2007
Yew, partly charred
Courtesy David Nash OBE RA
220 x 90 x 50 cms and 230 x 130 x 80 cms

Born 14th November 1945
Esher

David Nash studied at Kingston College of Art 1963-64, Brighton College of Art 1964-67 and (Post Graduate) the Chelsea School of Art 1969-70.

From his first series of solo exhibitions in the UK in 1973 his international reputation was quickly established with many further solo shows in North America, Europe and Japan, and each year since with his work entering more than 100 Public Collections in almost every continent.

He was awarded an OBE in 2004.

Trees exhibit an almost unlimited range of shapes, shakes, knots, lightning strikes and deformities reflecting the influence and harshness of their environment over time. For David Nash this is the starting point from which to enhance such natural form, burn, impact damage or ageing in the creation of his sometimes awesome and attractive works of art.

He lives and works in North Wales.

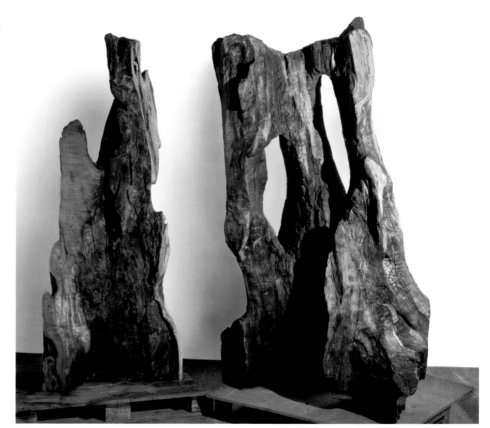

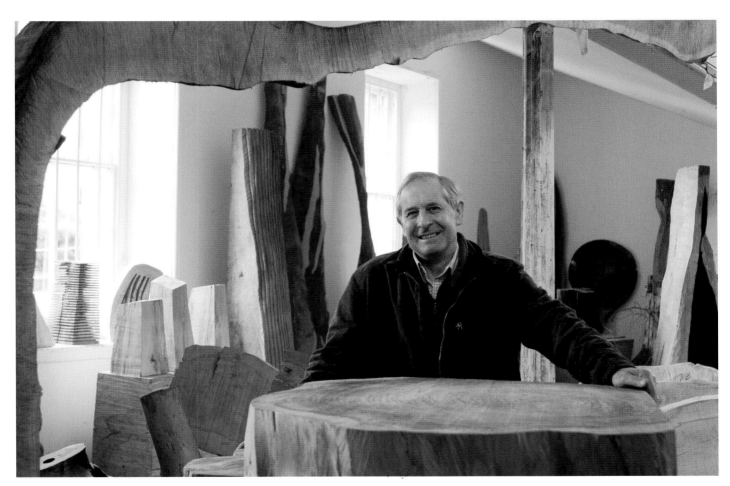

Elected RA 12th December 2006

Renewal of St Martin-in-the-Fields
Courtesy Eric Parry RA and
St Martin-in-the-Fields

Born 24th March 1952
Kuwait

Eric Parry studied architecture at the
University of Newcastle upon Tyne 1970-73
after which he went to the Royal College of Art
from 1976-78 and the Architectural
Association 1979-80 serving as its President
2005-07.

In 1983 he established his own practice and
has taught and served as examiner in various
schools of Architecture and Design in the UK,
USA and Japan, and continues to serve on a
number of professional and civic bodies.

His practice, which has won many awards,
encompasses an extremely wide range of
projects across cultural, academic,
commercial and residential fields. Examples
include a new Recital Hall for the Wells
Cathedral School, the restoration and renewal
of St Martin-in-the Fields Church and site,
several new office buildings in the City and
West End of London and the restoration of a
12th-century chateau in France.

He lives and works in London.

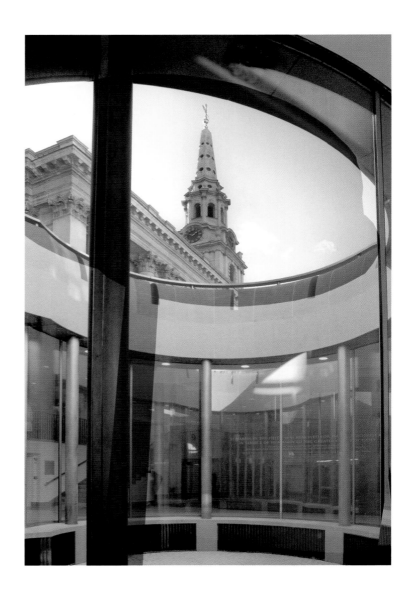

Elected ARA 21st May 1980
Elected RA 8th December 1988

*Chaucer College (Shumei University) for
Japanese Students, University of Kent
Campus*
Courtesy John Partridge CBE RA and
University of Kent, Canterbury

Born 26th August 1924
London

John Partridge studied at the Regent Street
Polytechnic (now University of Westminster)
and qualified in 1951. After working for
London County Council he became a founding
partner of Howell Killick Partridge & Amis the
partners of which were all working in the
department at the LCC. The practice was
formed on entering the competition for
Churchill College, Cambridge, the design for
which attracted numerous commissions and
more than 30 design awards.

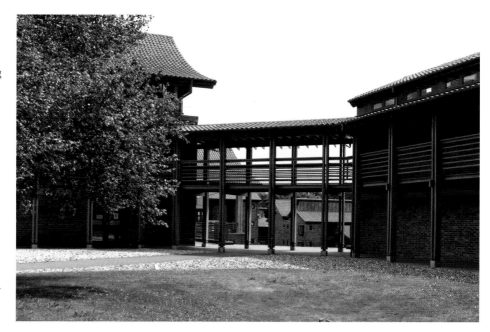

Before returning in 1995 John Partridge acted
as an Assessor for both the RIBA awards
scheme, and the Civic Trust Awards, and was
an external examiner at the Architectural
Association, Cambridge, Bath and Manchester
Universities and The Royal College of Art.

He has served on many RIBA committees and
was Vice-President from 1977-79. His many
completed works include buildings for St
Anne's College and St Antony's College,
Oxford, Reading University and Chaucer
College, Canterbury.

John Partridge lives and works in Kent.

Elected RA December 1998

Royal Shakespeare Company Courtyard
Theatre
Courtesy Ian Ritchie CBE RA

Born 24th June 1947
Hove

Ian Ritchie studied at the PCL, London (University of Westminster). After working with Norman Foster (1972-76) he spent two years in France designing and constructing projects. In 1979 he founded Chrysalis Architects and also worked at Arup's Lightweight Structures Group in London. In 1981 he set-up Ian Ritchie Architects in London, and co-founded the design engineering firm Rice Francis Ritchie (RFR) in Paris. Before leaving RFR in 1989, this practice had been responsible for major projects in Paris including Bioclimatic Facades at la Villette Cité des Sciences, and the Louvre Pyramids and Sculpture Courts with I M Pei.

Projects throughout Europe include Reina Sofia Museum of Modern Art Glass Towers, Madrid, the Leipzig Glass Hall, EdF Pylons, Dublin Spire and RSC Courtyard Theatre.

He and his practice have won more than 50 awards, including the prestigious French Académie d'Architecture Silver Medal for Innovation, and shortlisted four times for the RIBA Stirling Prize.

Ian Ritchie devotes much time to education and public duties and regularly presides on international juries.

He lives and works in London

RSC COURTYARD THEATRE 2/30

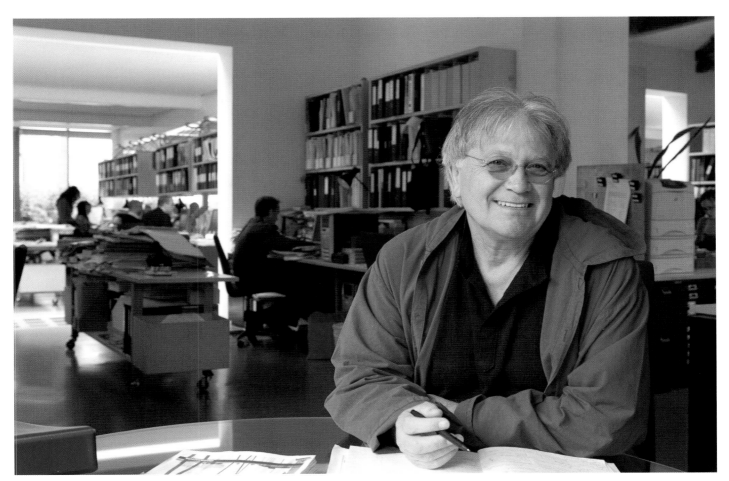

Elected RA 9th May 1984

88 Wood Street, City of London
Courtesy Lord Rogers CH RA

Born 23rd July 1933
Florence, Italy

Richard Rogers came to England in 1939 with his Anglo-Italian parents fleeing from Fascism in his native Italy. He studied at the Architectural Association 1954-59 and Yale 1961-62.

Richard Rogers met Norman Foster at Yale, and in 1963 founded 'Team 4' with their wives. The partnership dissolved in 1967.

Working with Renzo Piano, Rogers's the Pompidou Centre in Paris, completed in 1976, reshaped accepted forms of art and architecture and was – and remains – an enormous conceptual and technological achievement. This was followed by his Lloyd's of London Building another 'first' with its external services maximising an uncluttered and highly flexible interior work space.

Landmark buildings since then include the European Court of Human Rights, Madrid's Barajas Airport New Area Terminal, the National Assembly for Wales and Heathrow's Terminal 5.

His numerous awards include the Pritzker Architecture Prize (2007), the Légion d'Honneur (1986) and the RIBA Gold Medal (1985). He was knighted in 1991, made a Life Peer in 1996 and in 2008 he was made a Member of the Order of the Companions of Honour.

Richard Rogers believes that 'ideology cannot be divided from architecture and that change will clearly come from radical changes in social and political structures'.

He lives and works in London.

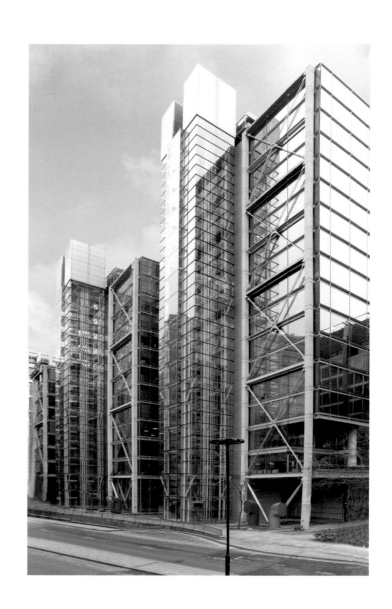

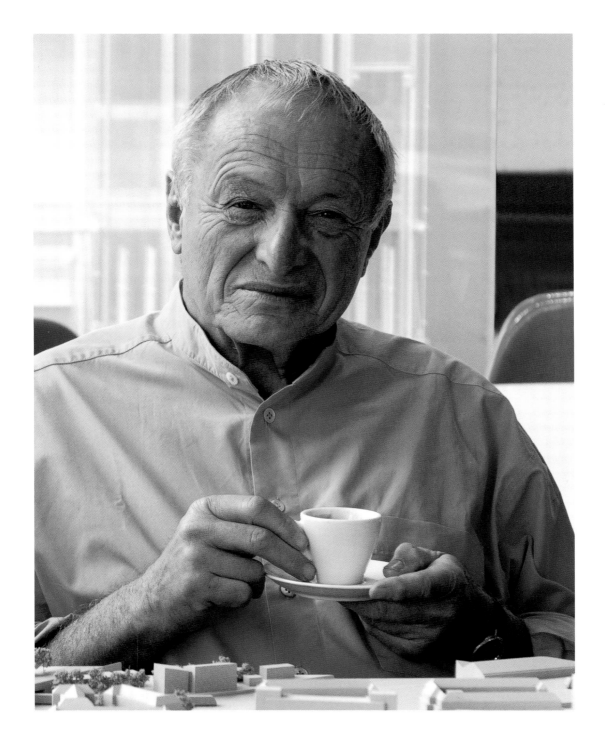

Elected RA 1989 Resigned 1998
Re-elected RA 26th May 2004

St George's Horse
Courtesy Michael Sandle RA

Born 18th May 1936
Weymouth

Michael Sandle studied at Douglas School of
Art and Technology, Isle of Man 1951-54
followed by two years National Service in the
Royal Artillery. He then studied at the Slade
School of Fine Art 1956-59 followed by a
period travelling in Europe before teaching at
various schools and universities in the UK,
Canada and Germany where, in 1973, he
became Professor of Sculpture at Pforzheim
and, in 1980, at the Akademie der Bildenden
Kunste in Karlsruhe.

Michael Sandle's early work found expression
in symbols representing his discomfort at the
social ills of the day, the futility of war and
injustices followed by monumental pieces in
public commissions – Memorial of the Victims
of a Helicopter Disaster (Mannheim 1985).
Malta Siege Memorial (1989-93), the
Seafarer's Memorial (2000) and, in much
smaller scale and different vein, his Belgrano
Medal – 'a Medal of Dishonour'.

His strong principles led him to resign from
the RA in 1987 in protest at the last straw of
the Myra Hindley exhibit in its 'Sensation'
show.

He lives and works in London.

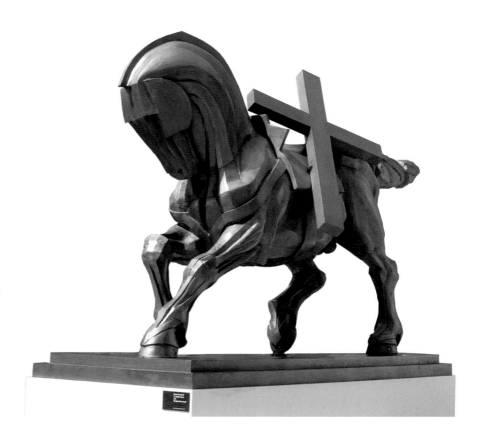

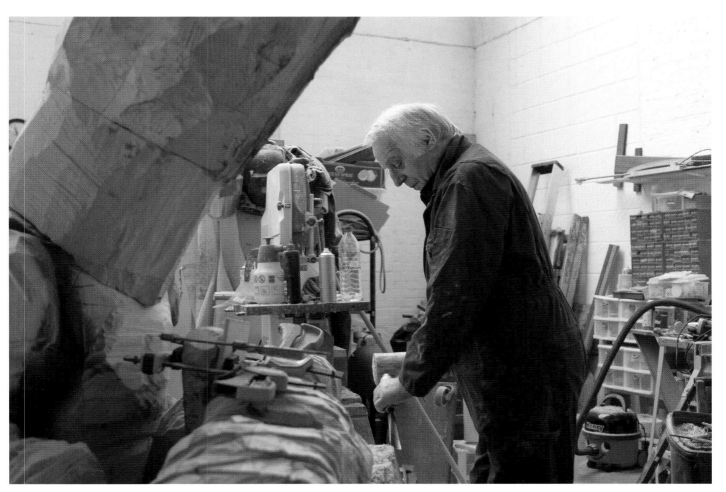

ALISON WILDING RA

Elected RA 15th November 1999

FUZZ 2008
Copper Wire, Ceramic
Courtesy the artist and Karsten Schubert
25 x 19 x 5.5 cm (variable)

Born 7th July 1948
Blackburn

Alison Wilding studied at Nottingham College of Art 1967-68. Ravensbourne College of Art 1968-71 and the Royal College of Art 1971-73.

She held her first solo exhibition at the Serpentine Gallery in 1985 and her first international solo exhibition at the Museum of Modern Art, New York in 1987. Since then she has exhibited widely in many countries including a retrospective at the Tate Gallery, Liverpool in 1991.

She was nominated for the Turner Prize in 1992 and received a Henry Moore Fellowship for the British School at Rome in 1998. Alison has work in public and private collections both in the UK and overseas.

Working in a variety of materials including wood, lead, galvanised steel, transparent plastics, fossils, paint, rubber, copper and beeswax, her work is often constructed in two elements enabling her to express contrasting – male-female – positive-negative – opposites.

Alison has said 'sculpture is that oddball thing that can sidestep language which is why it frustrates writers…'.

She lives and works in London.

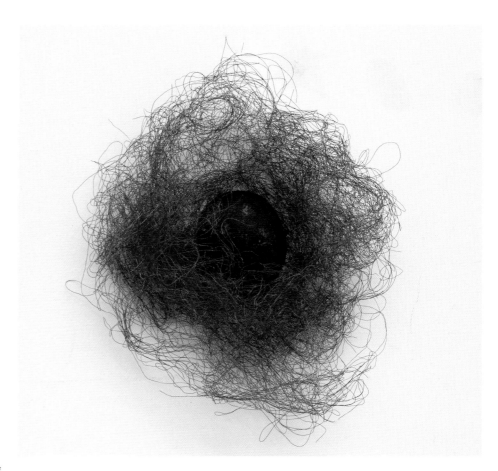

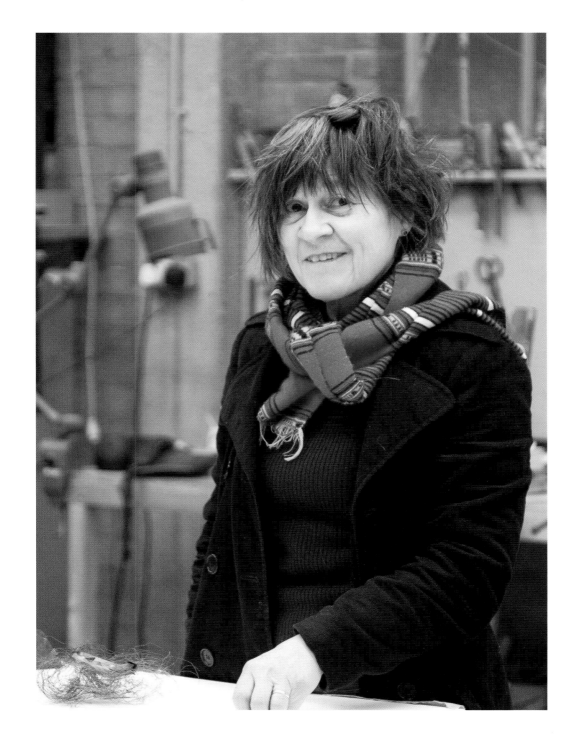

CHRIS WILKINSON OBE RA

Elected RA 27 March 2006

ACC LIVERPOOL Arena & Convention Centre
Courtesy Wilkinson Eyre Architects and
Liverpool City Council

Born 1 July 1945
Amersham

Chris Wilkinson studied Architecture at
Regent Street Polytechnic (now Westminster
University) from 1964-69 then joined Denys
Lasdun, Foster, Hopkins, Rogers until setting
up his own practice in 1983 and was joined
by James Eyre in 1986.

He has designed many award-winning
buildings including, Stratford Station,
Gateshead Millennium Bridge and the
Liverpool Arena and Convention Centre.

Chris says – 'there is a fundamental need
within us to experience man-made space of a
higher order. Perhaps we have a psychological
desire to see constructed space on the same
scale as nature in order to assert our place in
the universe. We are fortunate to be living in
an age of advanced technology which allows
us to design and construct much more
sophisticated forms than ever before but we
still cannot compete with nature which
provides the ultimate source of inspiration.'

He has won many awards, including the
Stirling Prize in two consecutive years, was
made OBE in 2000 and appointed an English
Heritage Commissioner in 2007.

He lives and works in London.

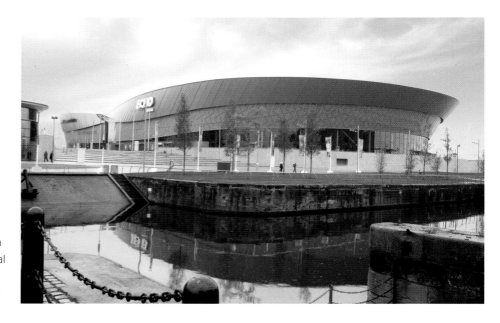

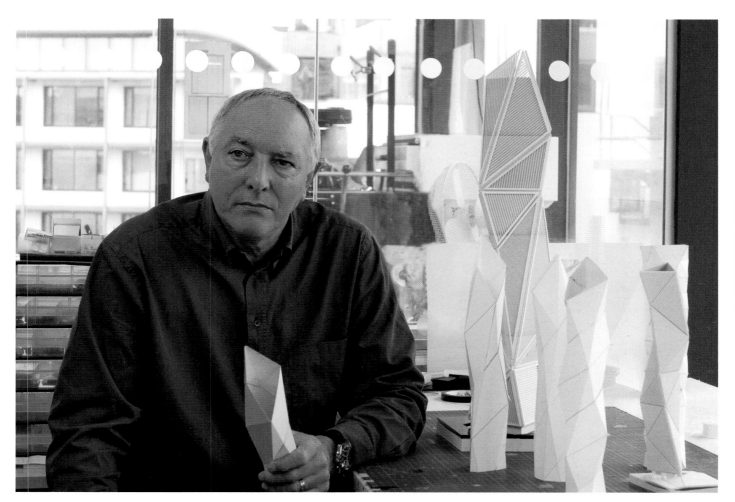

Elected RA 27th March 2006

A Slice of Reality
Courtesy Richard Wilson RA

Born 24th May 1953
London

Richard Wilson studied at the London College of Printing before attending the Hornsey College of Art 1971-74 and Reading University 1974-76. His first show '11 Pieces' was held in 1976 and since then he has had more than 50 solo exhibitions in the UK, Europe, USA, Japan, South America and Australia.

Richard says that he 'tweaks or undoes or changes interiors of space – and in that way unsettles or breaks people's preconceptions of space. What they think space might be'. In practice he is a conjuror who transforms mundane objects into surreal works of art which disorientate the viewer.

Typical of his work is 'Slice of Reality', illustrated, a slice of a vessel which he bought for the express purpose of cutting out the wheelhouse section and which measures 21 m high x 10 m wide x 9 m long. It is fixed to the bed of the Thames outside the Millennium Dome, originally as part of an open air sculpture exhibition at the site.

Richard lives and works in London.

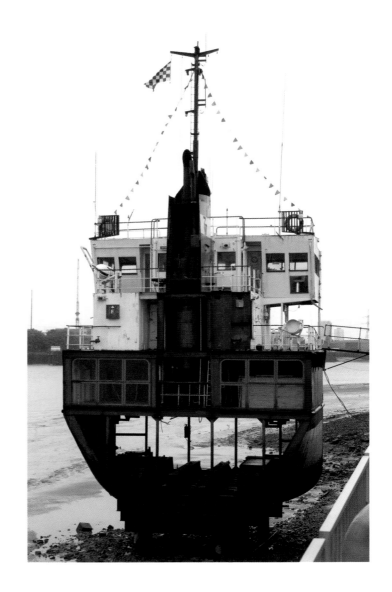

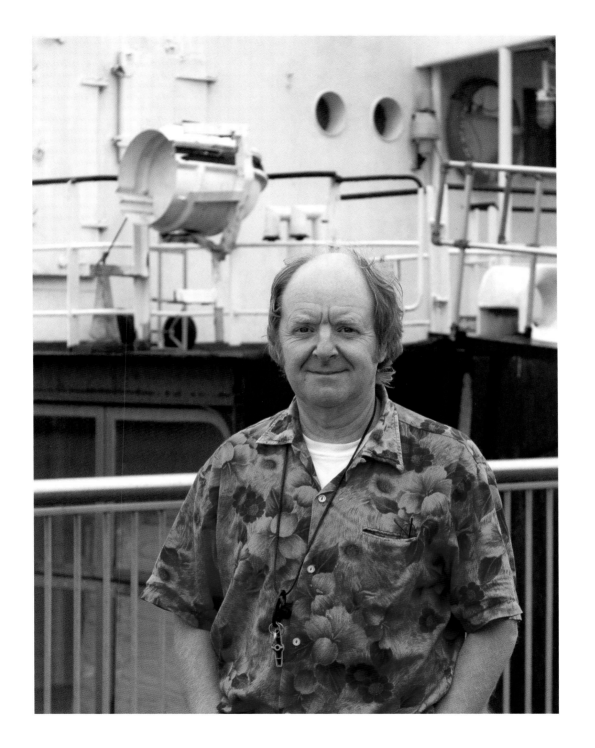

Elected RA 28th May 2002

Illuminator B 2008
Painted Bronze & Laminated MDF
Courtesy Waddington Galleries London
75 x 27 x 28 cm

Born 1st November 1948
near Henley on Thames

Bill Woodrow studied at Winchester School of
Art 1967-68, St Martin's School of Art
1968-71 and Chelsea School of Art 1971-72.
His first solo exhibition was at the Whitechapel
Gallery in 1972 and he went on to represent
Britain at the Biennales of Sydney (1982),
Paris (1982 and 1985) and Sao Paulo (1983).
He was also a Turner Prize finalist in 1986.

His work has been exhibited and collected
extensively throughout the world.

His early sculptures were made from found
objects and could be seen as a critique of
modern society. In the late 1980s he began to
expand his range of materials and continued
to make work that questions society and its
relationship to our planet.

He lives and works in London and Hampshire.

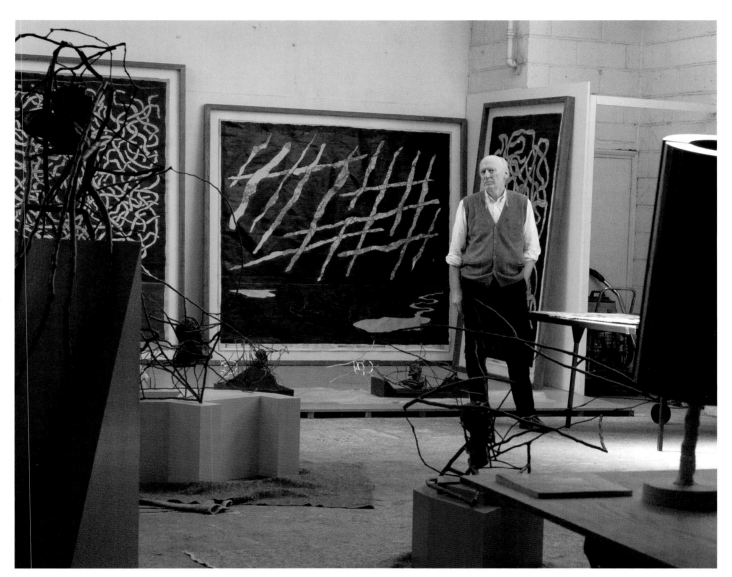

Elected ARA 18th May 1983
Elected RA 26th June 1991

Kafka
Courtesy John Wragg RA

Born 20th October 1937
York

John Wragg studied at York School of Art from 1953-56 and The Royal College of Art from 1956-60 after which he went on to teach at Chelsea College of Art until 1988.

He has won a number of awards including the Sainsbury Award Sculpture Competition, the Chantry Bequest and an Arts Council Major award. He has had many exhibitions since his first solo exhibition at the Hanover Gallery in 1963 and has work in museums, private and public collections including the Tate Gallery, the Israel Museum, Wellington Art Gallery, New Zealand and the National Gallery of Modern Art in Edinburgh.

Known principally for his sculptures whose subjects range from the human figure to abstract animated studies, John Wragg is equally interested in painting which he exhibits widely.

His Sainsbury Award, 'Embrace', consisting of anthropomorphic forms in the shape of two slender arcs which just touch each other, was rescued from its original site in the King's Road, Chelsea and re-sited in Milton Keynes after being vandalised.

He lives and works in Wiltshire.

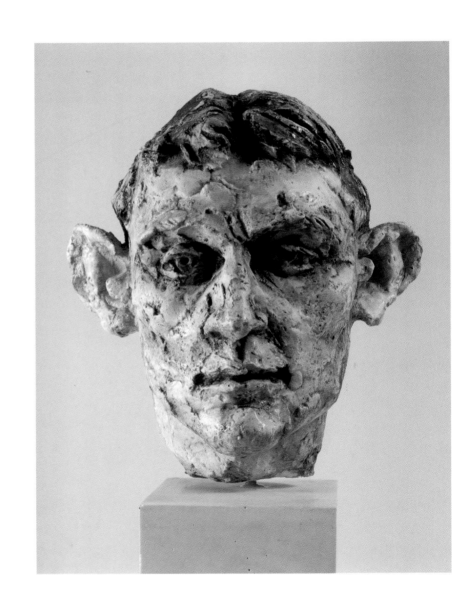

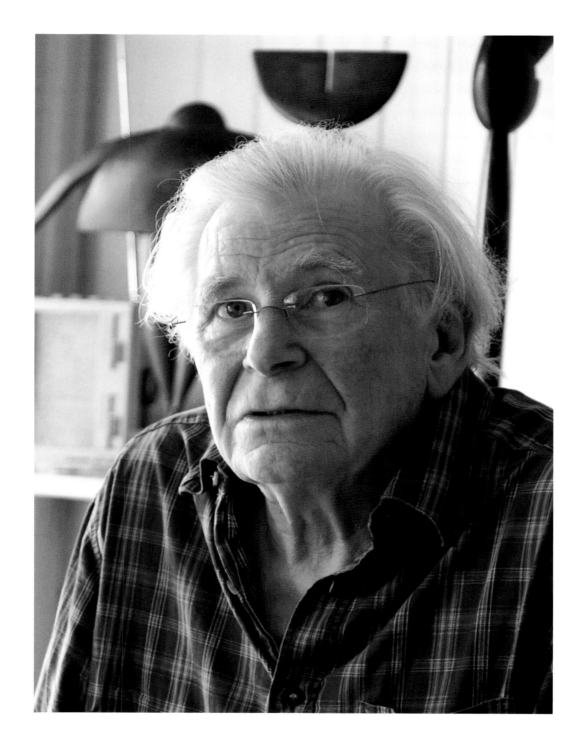

ABOUT THE AUTHOR

Dennis Toff (b 1926) trained at the School of Photography of the Regent Street Polytechnic (now University of Westminster) in 1942 and served in the photographic branch of the Fleet Air Arm during World War II. He left photography in 1950 to pursue a successful business career returning on retirement in 1993.

Since then his work has been exhibited in Australia, Austria, Denmark, France, Italy, Spain, USA and the UK including the Royal Photographic International Print Exhibition, The Association of Photographers Open, the London Salon of Photography, London Independent Photography Annual Exhibitions and the Mall Galleries. He has had solo exhibitions at Christchurch, Dorset and the Barbican Arts Library. In the USA his work can be seen in the Candace Dwan Gallery in New York.

Dennis Toff has work in the collections of The National Portrait Gallery, The London Jewish Museum and is a Fellow of the Royal Photographic Society.

Dennis Toff is the author of the first book in this set of two, *The Painter RAs*.

The portraits in this book form a Limited Edition of 15 Original Archival Pigment Prints of 33 cm x 48 cm each.

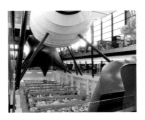
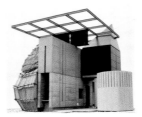

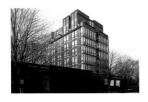
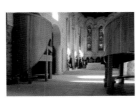

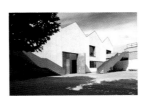
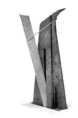
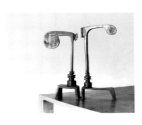

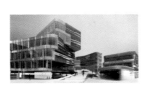
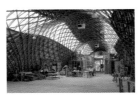
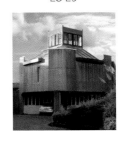
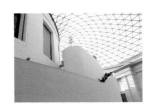

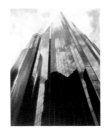

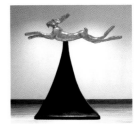

THE ARCHITECT & SCULPTOR RAs

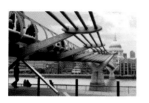

Lord Norman Foster OM RA
50-51

Antony Gormley OBE RA
52-53

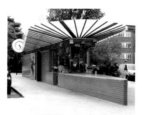

Piers Gough CBE RA
54-55

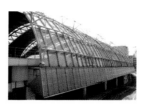

Sir Nicholas Grimshaw CBE PRA
56-57

Nigel Hall RA
58-59

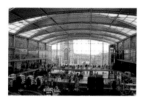

Sir Michael Hopkins CBE RA
60-61

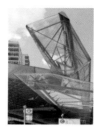

Eva Jiricna CBE RA
62-63

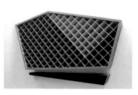

Phillip King CBE PPRA
64-65

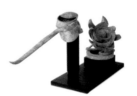

Bryan Kneale RA
66-67

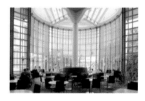

Paul Koralek CBE RA
68-69

Richard Long RA
70-71

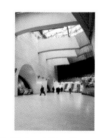

Sir Richard MacCormack
CBE MA PPRIBA RA
72-73

David Mach RA
74-75

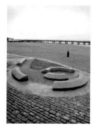

John Maine RA
76-77

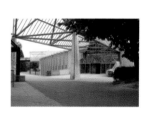

Leonard Manasseh OBE RA PPRWA
78-79

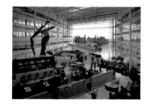

Michael Manser CBE RA PPRIBA
80-81

David Nash OBE RA
82-83

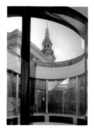

Eric Parry RA
84-85

John Partridge CBE RA
86-87

Ian Ritchie CBE RA
88-89

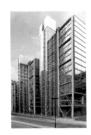

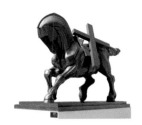

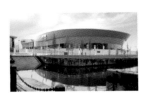

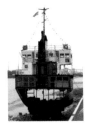

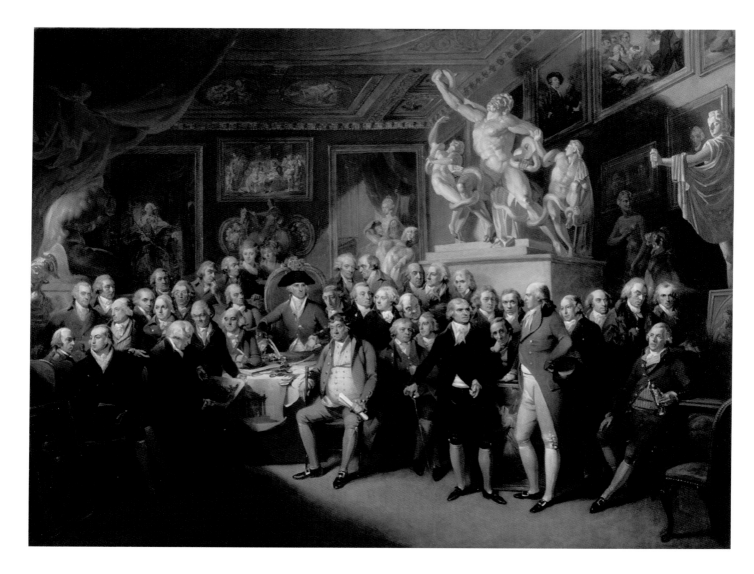

ROYAL ACADEMICIANS IN GENERAL ASSEMBLY 28TH MAY 2009
(WITH ACKNOWLEDGEMENT TO HENRY SINGLETON'S WORK OF 1795)

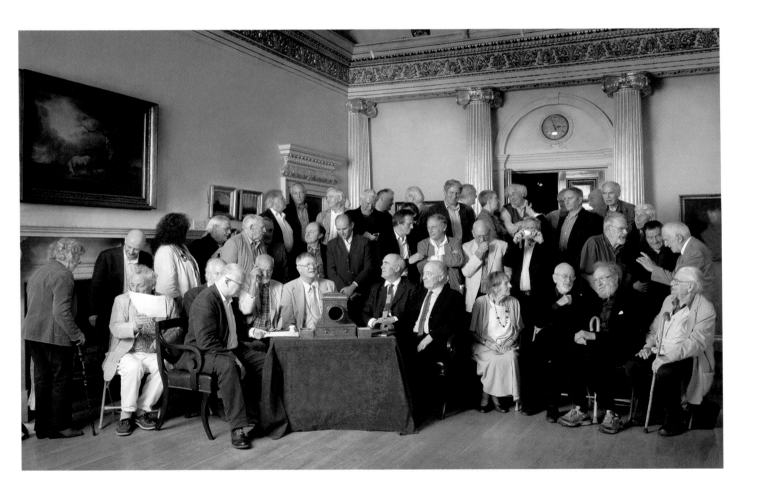

KEY

1. Sonia Lawson
2. David Remfry
3. Anthony Whishaw
4. Barbara Rae
5. Paul Huxley (Treasurer)
6. Philip Dowson (PPRA)
7. Mick Moon
8. Frederick Cuming
9. Phillip King (PPRA)
10. Edward Cullinan
11. Ian Ritchie
12. Nicholas Grimshaw (PRA)
13. Richard Wilson
14. Christopher Wilkinson
15. Spencer de Grey

16. Christopher Le Brun
17. Stephen Farthing
18. Charles Saumarez Smith
(Secretary and Chief Executive)
19. Stephen Chambers
20. Nigel Hall
21. Alison Wilding
22. John Carter
23. Norman Ackroyd
24. Maurice Cockrill (Keeper)
25. John Maine
26. Peter Freeth
27. Ann Christopher
28. Basil Beattie
29. Diana Armfield

30. Mick Rooney
31. Bill Jacklin
32. Jennifer Dickson
33. Tony Bevan
34. Chris Orr
35. Anthony Green
36. Albert Irvin
37. Joe Tilson
38. Anthony Eyton
39. Bryan Kneale
40. Trevor Dannatt
41. Gus Cummins
42. Anthony Caro
43. William Bowyer

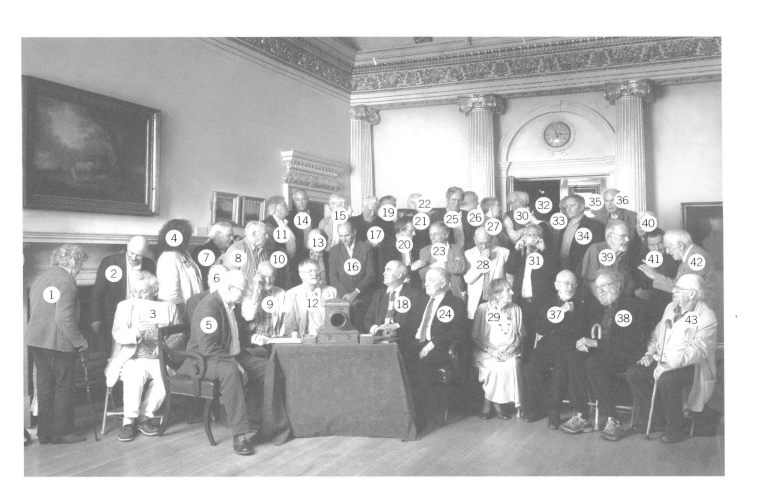